Chinese Export
Art and Design

AUSPICIO·REGIS·ET·SENATUS·ANGLIÆ

Chinese Export Art and Design

EDITOR
Craig Clunas

TEXTS
Craig Clunas · Verity Wilson · Rose Kerr · Nick Pearce

PHOTOGRAPHY
Ian Thomas

DESIGN
Patrick Yapp

VICTORIA AND ALBERT MUSEUM

Published by the Victoria and Albert Museum
First published in 1987

© Trustees of the Victoria and Albert Museum

Printed in Great Britain by Westerham Press Limited,
Westerham, Kent

ISBN 1 85177 000 3

Front cover:
DISH
Porcelain with decoration in underglaze blue
A lady and two gentlemen making music, taken from a
design by Robert Bonnart engraved by his brother
Nicolas Bonnart
About 1700–1710
Diameter 33.9 cm
C.781-1910
Salting Bequest

Back cover:
LID OF WORKBOX (No. *81*)
Carved ivory
About 1790–1810
1769-1892
Ingle Bequest

Reverse of cover:
PANEL OF PAINTED GAUZE-WEAVE SILK (detail)
Floral scrolling
About 1800
167 × 139.7 cm
T.119-1949
Munro Gift

Reverse of frontispiece:
ARMS OF THE HONOURABLE EAST INDIA
COMPANY
With the motto: *Auspicio Regis et Senatus Angliae*, 'Under
the Protection of the King and Parliament of England'
From a porcelain dessert basket (No. *61*)
About 1800–1805

Contents

Note on Spelling and Pronunciation

The *pinyin* system of romanizing the China script is used throughout, with the exception of certain well established place names such as Peking, Canton and Hong Kong. This system represents the sounds of Modern Standard Chinese (*putonghua*), rather than the Cantonese which was the language of many of the people referred to here, but it has been employed for consistency.

The following few hints may help the reader unfamiliar with the system at least to pronounce words to themselves:

Initial *c*–, as English *ts*–
Initial *q*–, as English *ch*–
Initial *x*–, as English *s*–
Initial *zh*–, as English *j*–

Acknowledgements

The complexities of a new gallery installation and of a major publication involve most of the skills within the Museum. In addition to the authors, all staff of the Far Eastern Department have played major parts in bringing the project to fruition: Helen White planned and executed a complicated photographic programme, Amanda Ward ensured the smooth flow of objects through the hands of the Conservation Department, while Amanda Proctor organized effective office support. They, Rupert Faulkner and Julia Hutt have worked willingly at all times on the unglamorous but necessary tasks which the gallery and the book have demanded. Specialists in all the conservation disciplines need to be thanked for their energetic application of skills, as well as their openness with advice and informed opinion. A particularly heavy burden has fallen on Ceramics Conservation Section, where Sue Service has coped with an increased workload, while at the same time restoring the porcelain pagoda to its position as one of the Museum's most splendid treasures.

As Keeper of the Far Eastern Department and latterly as Head of Public Services, Joe Earle has always been on hand with encouragement and forceful support, as has Julie Laird. In the Museum's Works and Exhibitions Sections, Phil Phillips, Garth Hall and Andrew Hiskens have managed the technical demands of the project, while George Jackson, Charles Kennett, Fred Harrison and their staffs have arranged its detailed execution. For Michael Hopkins and Partners, Patty Hopkins, Ian Sharratt, Sheila Thompson and Robin Snell have worked to integrate this gallery into their vision of a total reinstatement of the Museum's architectural splendours, and have designed an installation which sets new standards in the presentation of a collection.

The authors have benefited from the writings and opinions of many scholars, and have received unstinting help from a number of colleagues inside and outside the V&A; Sir Geoffrey de Bellaigue, Richard Capurso, Merrill Huxtable, Ronald Lightbown, Pauline Webber, John Mallet and Michael Snodin.

The true begetter of this project has been Gerald Godfrey, who has perceived the possibilities of a role for Chinese Export Art and Design in the V&A with verve and enthusiasm. His willingness to translate ideas into reality, his sympathetic support at all times and his real understanding of the Museum's potential have made him an ideal sponsor, and one whose impact on the project goes well beyond financial generosity.

Craig Clunas
Far Eastern Department
April 1987

Prefaces

Having lived in Asia for some thirty years, I feel privileged to be able to contribute to my early source of inspiration, the Victoria and Albert Museum. The new gallery of Chinese Export Art and Design which this book so admirably illustrates will certainly be a stimulus in many different ways to a variety of people.

The term 'Chinese Export Art' implies for me the essence of the best aspects of international trade – the making and shipping of objects of artistic merit in response to a specific demand, employing special local skills and materials unobtainable at the place of destination. The merchandise involved in this trade was designed not merely for use but also intrinsically for adornment, decoration, virtuosity and curiosity – in short, for pleasure. The interplay of exotica from China with the contemporary uses to which these objects were put created a fashion which has endured up to the present day in the western taste for 'things Chinese'.

In looking at the objects pictured here and displayed in the gallery, one is struck by the very strong elements of freshness, gaiety and freedom of design, combined with the skills and easy vision of the Chinese artist-craftsmen who created them. The people who used and enjoyed these objects in the eighteenth and nineteenth centuries surely experienced a blend of the senses of wonderment, pleasure and novelty which we still feel today.

As a young man I remember walking through the V&A, seeing a few Chinese export pieces scattered here and there, and being thrilled in unexpected corners by unexpected objects. Now the bringing together of these special objects produces a sensation of the original joy with which they must have been received in England one or two centuries ago.

Gerald Godfrey

The Victoria and Albert Museum houses one of the most important collections of artefacts made in China for export to the West, dating from the first sea-borne contacts between the two civilizations in the sixteenth century down to our own time. These rich holdings of porcelain, silk, lacquer, carving and painting have been assembled over more than a century since 1852. The Far Eastern Department, founded in 1970, made the extension of this area of collecting one of its priorities, and many of the finest items reproduced here and shown in the Museum's new Gallery of Chinese Export Art and Design have come to us in recent years. However no space has until now been made available for the display of these physical testimonies to one of the great themes of world history – the commercial and cultural impact of the China Trade on Europe and Asia. The pieces shown here are part of the cultural history of Britain, and not least of the Chinese community in Britain, many of whom have ties to the Canton delta region where so much Chinese export art was produced.

At a time of closer understanding between China and Britain, it is particularly fitting that generous sponsorship from Hong Kong should come forward to create a permanent Chinese export gallery within the National Museum of Art and Design. The vision and commitment of Mr Gerald Godfrey have not only ensured the highest standards of care and display for the collection, but have made possible this splendid publication.

The Lord Carrington KG
Chairman of the Board of Trustees of the Victoria and Albert Museum

Introduction

THE lure of luxury goods from the workshops of China's craft producers was felt by other Asian peoples for centuries before the arrival of the Portuguese in East Asian waters in 1514. The highly developed Chinese craft market was able to satisfy its foreign customers with distinctive shapes and decoration, which met the requirements of societies very different from that in which the ceramics, metalwork, textiles and lacquers were produced. The ceramic kilns of Jingdezhen and the silk looms of Nanjing, both located hundreds of miles from the ports where trade took place, were already well able to produce objects to designs dictated by the requirements of customers whom the potters and weavers had never seen. The financial structures of complex seasonal trade were also in place, with the rise, particularly in the Ming period (1368–1644), of a flexible and entrepreneurial business class. There is therefore something rather artificial in separating off those goods made for European (and later American) customers, often to western designs, and calling them 'Chinese export art'. However the irruption of western trading ships and warships (the two were often indistinguishable) into the Indian and Pacific Oceans was to have major consequences, which were to be far greater for both Chinese and western civilization than those brought about by the age-old interaction between the economies of Asia. There is a sense in which the world we live in now owes much of its form and many of its tensions to the creation of an integrated world economic system, which began with the western search for luxury goods in Asia, such as drugs, spices, tea, textiles and porcelain.

The very widespread availability of Chinese goods in Britain, particularly from the early eighteenth century, and their ubiquity in country house interiors which survive from the period, have sometimes led to the study of export art being subsumed into the history of those interiors. Thus Chinese ceramics, furnishing fabrics, wallpapers and furniture are sometimes treated as honorary British objects, with little consciousness of the cultural context from which they sprang. Yet despite their western shapes and decoration, they remain a part of the history of the material culture of China, and in particular of Canton, the great port city on the south coast which was for the most active hundred years of the China trade the sole point of commercial contact. Situated on the delta of the Pearl River, Canton was the natural point of contact between the Chinese empire and the cultural worlds of the Indian Ocean and South-east Asia. There had been a colony of Arab merchants there since at least the Tang dynasty (618–906 AD). Thus it was natural that it should be the first port visited by the early Portuguese voyagers, who were also frequent visitsors to its commercial rivals further up the coast, Quanzhou, Zhangzhou, Xiamen (Amoy) and Ningbo. It was a deliberate act of imperial policy to attempt to restrict the trade to Canton from 1729. There it was closely supervised by an official who belonged not to the regular bureaucracy

1
PORTRAIT FIGURE OF A WESTERN MERCHANT
Painted clay on a bamboo armature, with lacquered wood case
About 1710–1725
Height of figure 29.5 cm
FE.32-1981

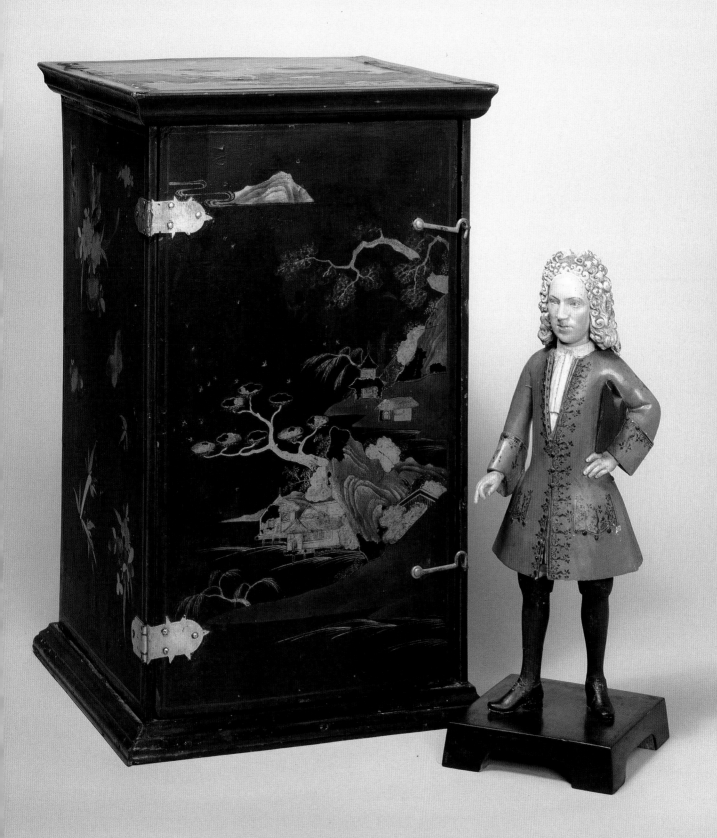

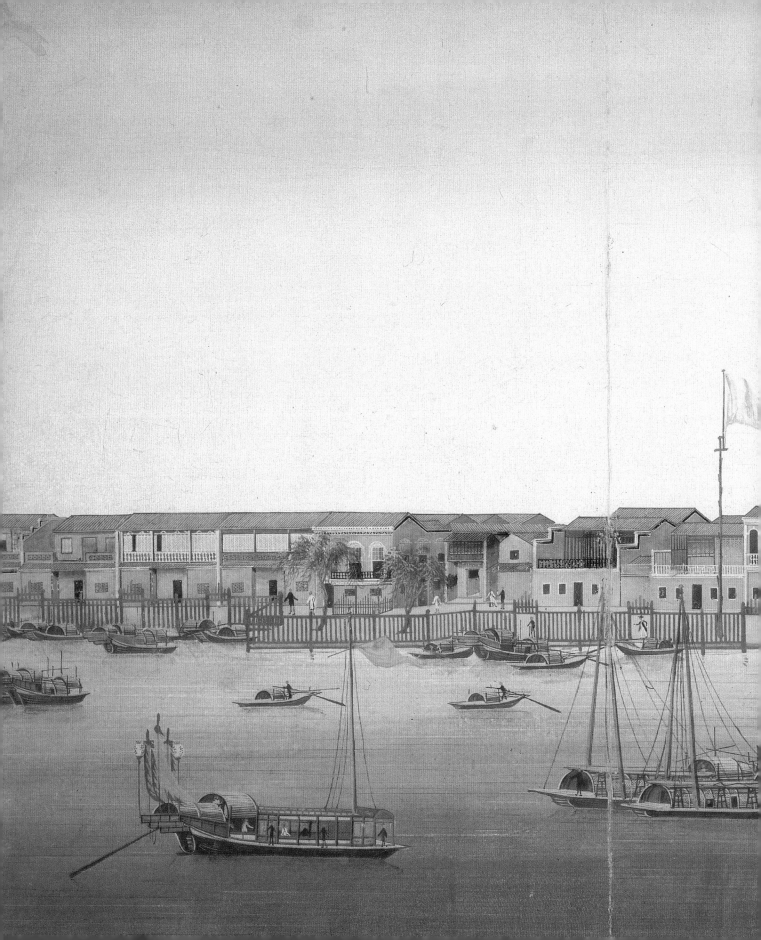

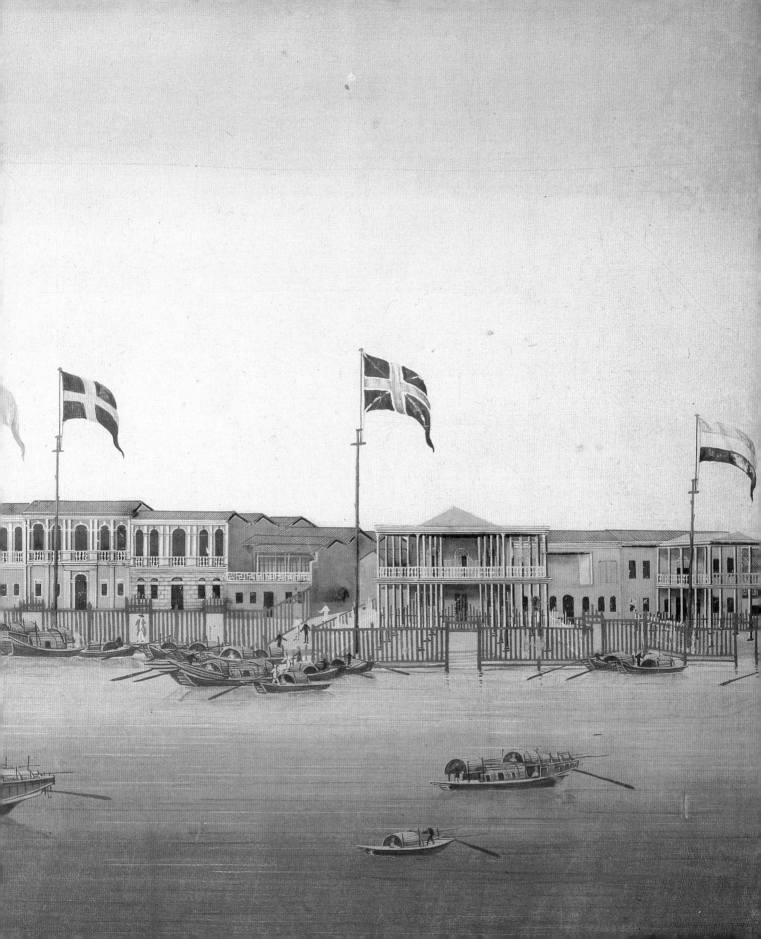

but to the Imperial Household Department. The major Chinese beneficiary of the trade was thus the emperor himself.

The traditional bias towards the study of the consumption, rather than the production, of Chinese export goods is perhaps understandable given the relative richness of information on the former topic, compared with the silence from the Chinese end. Trade with the West involved only a small number of merchants and bureaucrats. It was of little interest to the Chinese political or intellectual élite. Even an observer as acute as the writer Shen Fu (1763–after 1807), who visited Canton in the early 1790s in the course of a trading venture of his own and remarked on all sorts of colourful local details, was utterly unmoved by a distant prospect of the western trading factories (combined offices, warehouses and living-quarters) spread out along a section of the waterfront. He remarked casually that the western buildings he saw there 'looked just like those in a western painting.' He showed no curiosity about their occupants. A Chinese export watercolour of about 1780–1783 (2) shows, from right to left, the factories of the Dutch, English, Swedish, Imperial (for the Holy Roman Empire) and French East India Companies. The Danish factory is out of the picture to the left.

In the eighteenth and early nineteenth centuries, western trade at Canton was a strictly seasonal affair, the timing of which was dictated by the shifting winds of the Indian Ocean. From the English side, it was dominated by the Honourable East India Company, a joint stock company established under royal charter granting it a monopoly on trade with India and the Far East. This highly profitable enterprise, which by the 1680s was paying an annual dividend of twenty per cent on its stock, and importing fourteen per cent of England's total imports by value, was still more profitable for its individual employees. Several enduring fortunes were built on the basis of successful voyages to the East Indies. This was largely due to the Company's policy of allowing its captains, 'supercargoes' (or chief negotiators) and other officers down to the crews of its ships, to engage in a specified amount of private trading to their individual profit. It was this private trading which brought to Britain the kind of commodities discussed in this book, and which created a revolution in perception, affecting all fields of art and design.

The Honourable East India Company generally limited its purchasing in Canton to the fields of tea, silk and porcelain bought in bulk. Of these, tea was by far the most important in terms of both quantity and value. It was the only Chinese commodity against which protectionist agitation could not be organized in Britain. The first year of substantial imports was 1678, but regular shipments only began as late as 1717. The next commodity in order of importance was raw silk, destined for the looms of Spitalfields and elsewhere. Chinese woven silks were less important, and for the bulk of the eighteenth century it was only in very occasional years that they formed more than one or two per cent by value of the total cargo. Porcelain was of course a bulky item, and one imported in staggering numbers of individual items, but again after 1717 it never formed more than two per cent of the cargo by value. Even in relation to the private trade of individuals, the objects shown in this book formed the minor part of that minor part of the trade. From the 1720s to the 1750s, gold was the most popular private export from China, to be succeeded in time by tea. Lacquer, fans and even porcelain had

2 (*previous pages*)
THE CANTON
WATERFRONT
Watercolour on silk
About 1780–1783
53.3 × 32.4 cm
D.448-1887

3 (*right*)
PLATE
Porcelain with decoration in
overglaze enamels
Arms of Lee quartering Astley,
with views of London and the Pearl
River at Canton
About 1730
Diameter 25.1 cm
C.72-1963
Basil Ionides Bequest

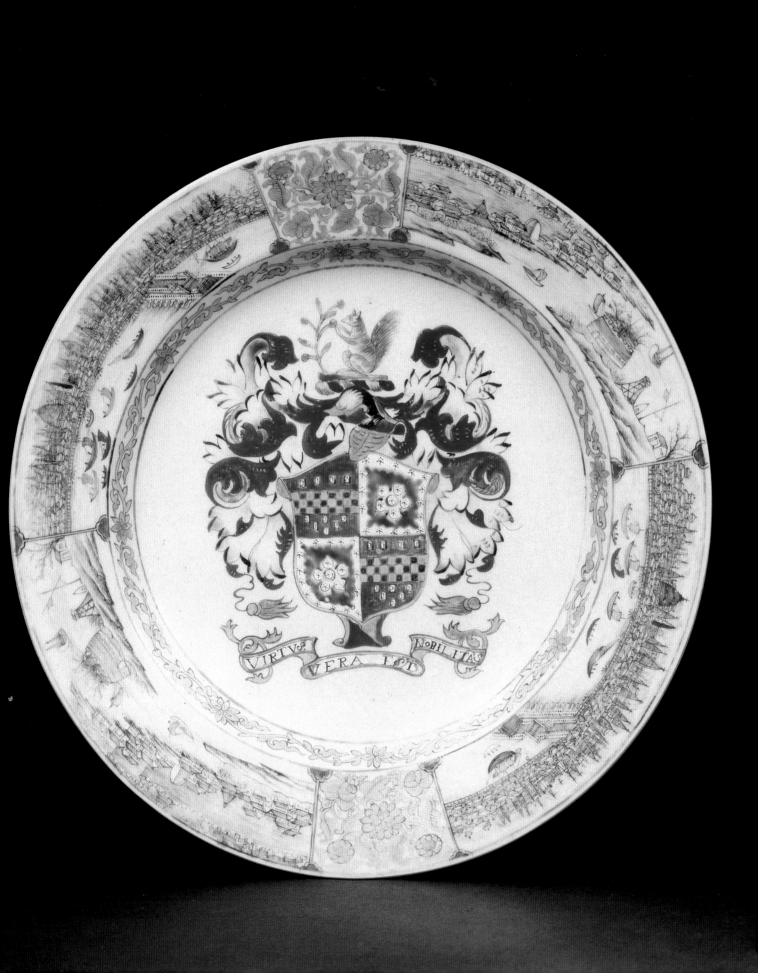

VIRTVS VERA EST NOBILITAS

by the end of the eighteenth century dwindled to the level of occasional souvenirs. This pattern was to be continued in the following century. The search for a replacement for silver, which had hitherto been the only western import actively desired by the Chinese economy, led to the massive expansion of the trade in opium. This systematic crime against humanity led directly to armed British intervention in China in the First Opium War of 1839–1842, to the occupation of Hong Kong and the opening of other 'treaty ports' to western trade, and to the incorporation of China in a world trading system. What had begun as a western search for Chinese goods was now transformed into a forcible entry for British goods into the vast Chinese domestic market.

The phases of design history which are revealed by a study of the goods actually exported from China were intimately associated with the shifting balance of economic and even intellectual power between China and its western customers. With the exception of occasional rare curiosities such as porcelain with sixteenth-century Portuguese coats of arms (*12*), the earliest artefacts supplied specifically to western customers are not distinguished by decoration drawn from the western tradition. If anything, it is the shapes of objects which are modified to suit a western way of life. Objects such as the porcelain tankard (*13*), or small lacquered coffer (*62*), carry decoration which is entirely within the Chinese tradition, and which would also have been applied to objects destined for the internal market, even though their shapes are explicitly designed for export. This is the phase which predominates throughout the seventeenth century. In the following century, as the sheer novelty of the new materials and decorative techniques began to pall, customers in the West looked to Chinese workshops to supply goods looking no different from those they could have made at home, albeit at a higher price. This is the phase of armorial porcelain, of silk textiles which aim to copy the products of European looms, and of cheap imitations of English table silver. It is the phase in which the balance of the relationship tilted from the producer to the customer, no longer happy to take what was already on offer, but actively intervening to ensure the manufacture of goods saleable in a market on the other side of the world. The mechanisms of western intervention in the world of Chinese design are as yet little understood. Occasionally actual objects must have been taken to China to be copied, such as the complex figure group of 'Dutch Dancers' (*53*). Engraved bookplates were certainly sent to Canton (and from there must have travelled inland to Jingdezhen) as the patterns for armorial porcelain. Engravings, such as Hogarth's 'Calais Gate', were also supplied (*55*). This influx of western graphic material through Canton must have had a more widespread effect on the visual culture of late imperial China than did the tiny handful of western Jesuit painters at the imperial court, who have been intensively studied. Drawn designs for the shape of objects, as well as for their decoration, were also supplied to Canton. These spread the conventions of fixed-point perspective, and the very idea of a 'design' as a graphic two-dimensional representation of a three-dimensional thing, throughout the world of traditional Chinese craftsmanship. Thus parallel with the well-known growth of *chinoiserie* (a term loosely applied to any decoration of even remotely Asian derivation) in the West, went the slower spread within the Chinese crafts of *yang shi*, 'oceanic (i.e. western) styles'. On an eighteenth-century porcelain box (*4*), it is hard to say whether the

4
FOOD BOX
Porcelain with decoration in overglaze enamels
Westerners and western ships
About 1700–1720
Diameter 27 cm
C.1147-1910
Salting Bequest

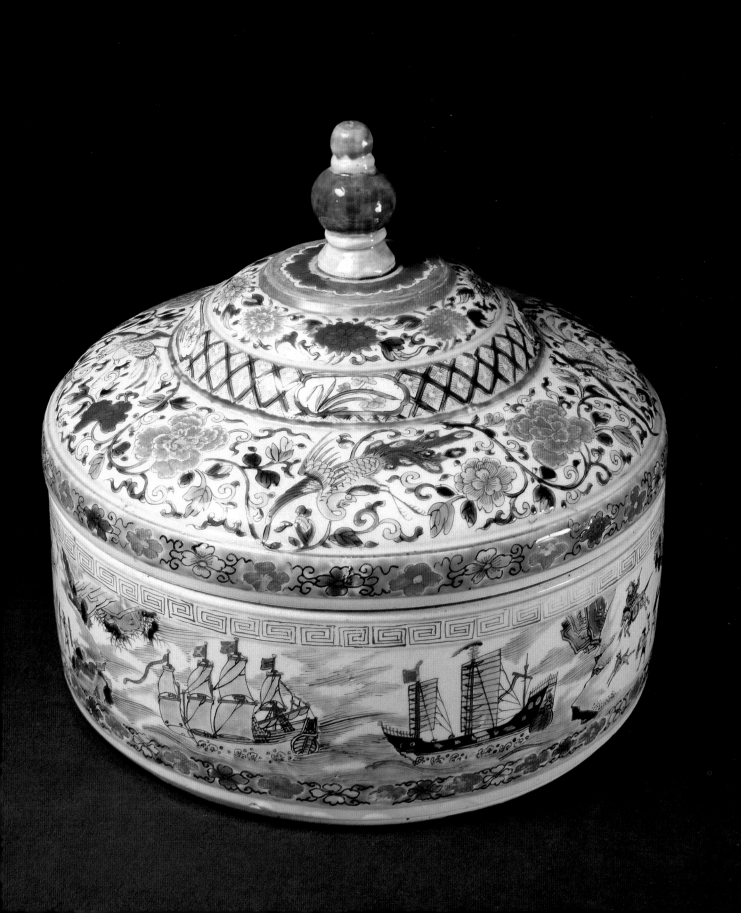

western merchants and western ships are destined as a reflection of themselves for western customers, or are an exotic touch on an object aimed at a Chinese buyer.

As the eighteenth century progressed it was increasingly the *chinoiseries* which formed the decorative subjects of export art and design. This eventually gave way to a third and final phase which, though it may at first sight appear to be a return to decoration drawn from the Chinese tradition, is in fact a debased exoticism, signalling in the design sphere China's increasing political and economic subordination to the West. Dragons, bamboos and pagodas are combined and recombined to emphasize a stereotyped 'mysterious East'. This process, where Chinese culture was reduced to a few hackneyed images, took place at the very period when the West, in particular Britain, was enforcing its political and economic hegemony in the Far East. With this, China's craft traditions began a descent into tourist art from which, despite China's recovery of national sovereignty and intellectual vitality in our own time, they have still to an extent to emerge.

The objects shown here then are, as well as continuing bringers of visual delight, in a sense the fall-out as well as one of the causes of European expansion. Spices, tea, silks and porcelain sent ships and armies round the world, established colonies and concessions on all five continents and created some of the empires in the shadows of whose overthrow we live today. CC

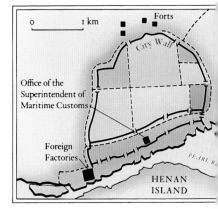

CANTON IN THE QING DYNASTY (1644–1911) (*above*)

CANTON AND THE PEARL RIVER ESTUARY (*opposite*)

CHINA AND SURROUNDING REGIONS (*opposite insert*)

CITIES AND TOWNS IN THE CANTON AREA

Canton (*Guangzhou*)	Shunde
Zhaoqing	Zhongshan
Jiangmen	Macao (*Aomen*)
Sanshui	Kowloon (*Jiulong*)
Foshan	Hong Kong (*Xianggang*)
Panyu	Huizhou

CITIES AND TOWNS MENTIONED IN THE TEXT

Canton (*Guangzhou*)	Yixing
Peking (*Beijing*)	Dehua
Shanghai	Fuzhou
Nanjing	Quanzhou
Hangzhou	Zhangzhou
Suzhou	Amoy (*Xiamen*)
Jingdezhen	Ningbo

OTHER GEOGRAPHICAL FEATURES AND NEIGHBOURING REGIONS

Yangtze River	South China Sea
Yellow River	Korea
Taiwan	Philippines
Indian Ocean	India
Pacific Ocean	

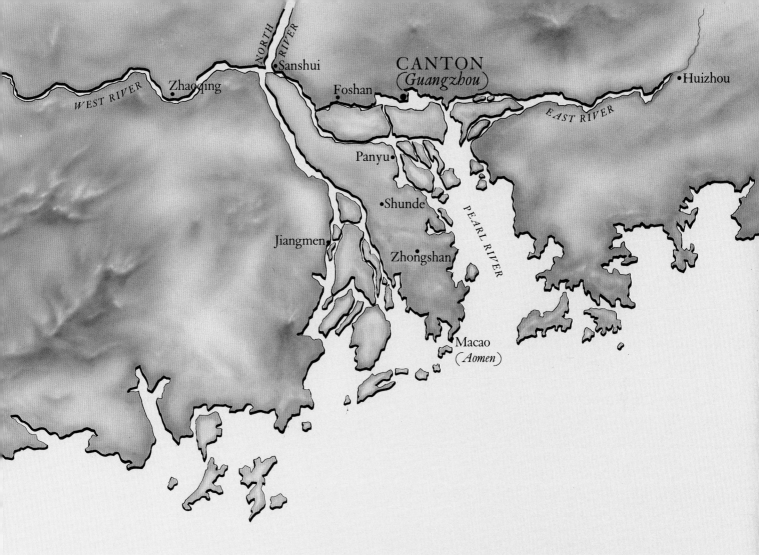

WEST RIVER
Zhaoqing
NORTH RIVER
Sanshui
Foshan
CANTON
(*Guangzhou*)
Huizhou
EAST RIVER
Panyu
Shunde
PEARL RIVER
Jiangmen
Zhongshan
Macao
(*Aomen*)

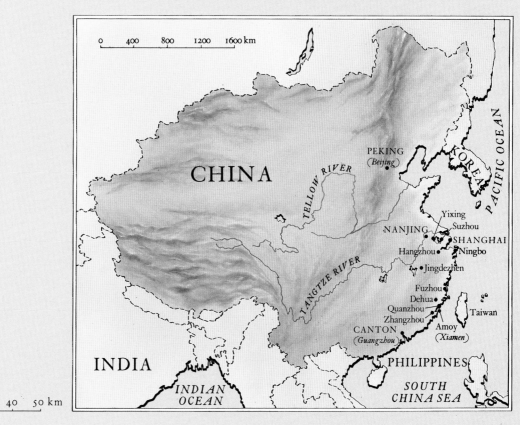

0 400 800 1200 1600 km

CHINA

PEKING
(*Beijing*)

YELLOW RIVER

KOREA

PACIFIC OCEAN

Yixing
NANJING
Suzhou
SHANGHAI
Hangzhou
Ningbo

YANGTZE RIVER

Jingdezhen

Fuzhou
Dehua
Quanzhou
Zhangzhou
Amoy
(*Xiamen*)
Taiwan

CANTON
(*Guangzhou*)

INDIA

PHILIPPINES

INDIAN OCEAN

SOUTH CHINA SEA

0 10 20 30 40 50 km

Silk

To the Romans, China was the 'land of silk', a major source of highly desirable luxury textiles. It was certainly the culture where the technology involved in rearing the larvae of certain species of moth, in order to spin the material of their cocoons into yarn, was first developed and brought to its highest refinement. The production of silk, in a number of centres distributed throughout the empire, was one of the mainstays of the pre-modern Chinese economy, second only to agriculture in its value to the state and in the number of families for which it provided a means of support. Silk was also the first of China's luxury craft products to be exported in large quantities, both along the 'Silk Road' to the opposite side of the Eurasian landmass, and by sea to the rest of Asia. Silk textiles were one of the major lures which brought merchants from the Islamic and Indian worlds, as well as from Japan, to the port cities of China, and they were eagerly sought by the first European merchants to reach Canton, itself the centre of a major weaving region. As early as the sixteenth century, Chinese weaving workshops were producing textiles with patterns of identifiably European origin.

The trade in silk from Canton was immensely valuable in the seventeenth and eighteenth centuries. However it was as raw silk that the bulk of the material was exported. Piece-goods, that is textiles finished either by patterning on the loom, embroidering or painting, formed only a very small part of the total by value. From 1709 to 1760, through the supposed height of the fashion for exotic imported textiles in Britain, silk piece-goods never formed more than five per cent of total imports from China by value. In most of those years they were less than one per cent of imports by value. These finished items were the private trade of individuals, bought from the 'shopmen', who were outside the system of licensed merchants in bulk commodities like tea and raw silk.

Given this often personal connection, it is perhaps surprising that personalized textiles, such as those decorated with western coats of arms, are almost unknown. One very rare example is a now curiously shaped fragment (5) decorated with the arms of James Brydges, created first Duke of Chandos in 1719, impaling those of Cassandra Willoughby, his second wife, who died in 1735. It may have formed part of a complete set of satin bed-hangings worked with the Chandos arms which, together with two lacquered screens and a service of porcelain, were bought in Canton by a relative anxious to ingratiate himself with this powerful magnate, much of whose immense wealth originated in holdings of East India Company shares.

Sets of embroidered bed-hangings, together with single bedspreads, were generally made from cream or pale yellow silk. The silk here is of a satin weave, and seems to have been recut to give a horizontal seam across the bottom third. The majority of export bedspreads (6) are by contrast formed out of three loom-widths, seamed along their length. Further alteration has taken place with

5 (right)
FRAGMENT OF A BED
HANGING
Silk with decoration in silk
embroidery and appliqué velvet
Arms of James Brydges, Duke of
Chandos
About 1730
115.6 × 68.6 cm
T.113-1916
Reynolds Gift

6 (overleaf)
BEDSPREAD
Silk decorated with silk
embroidery
About 1770–1790
218.4 × 179.1 cm
T.387-1970
Given by
Mr and Mrs G. H. G. Norman

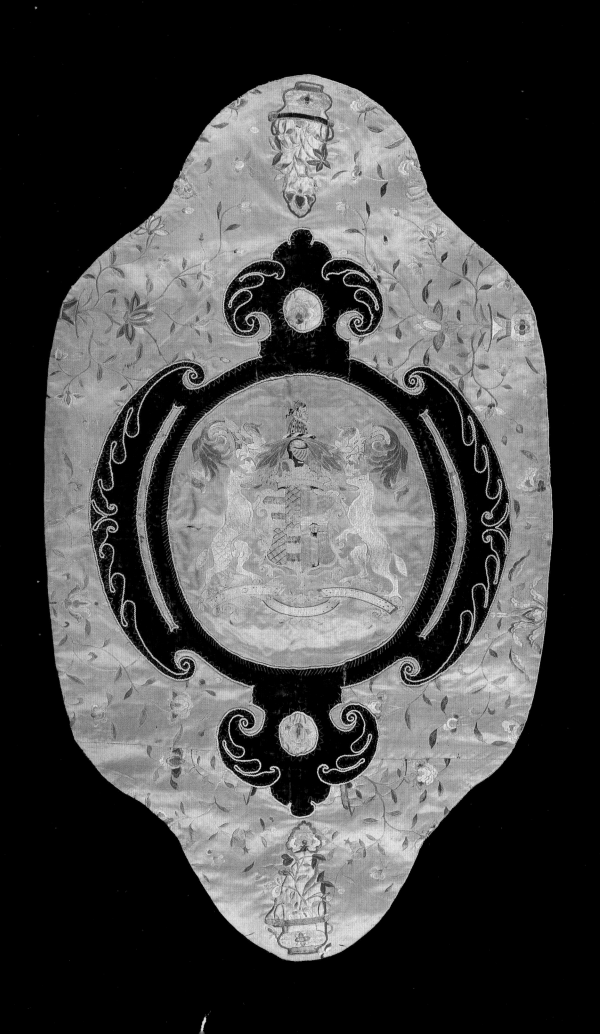

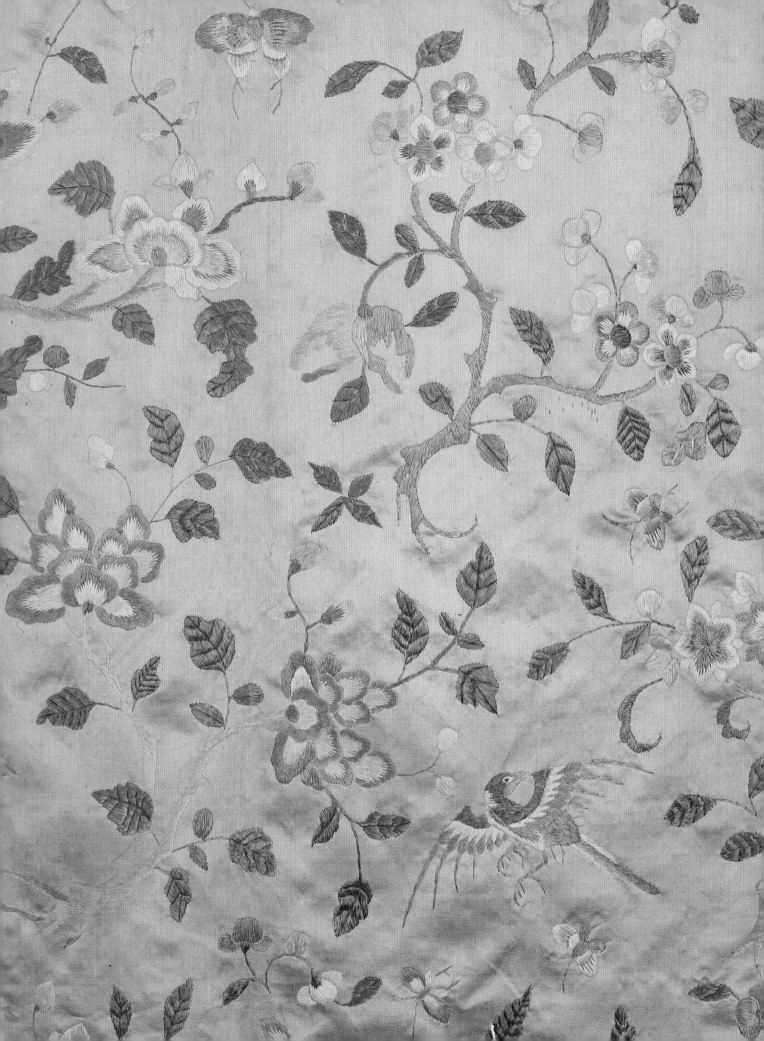

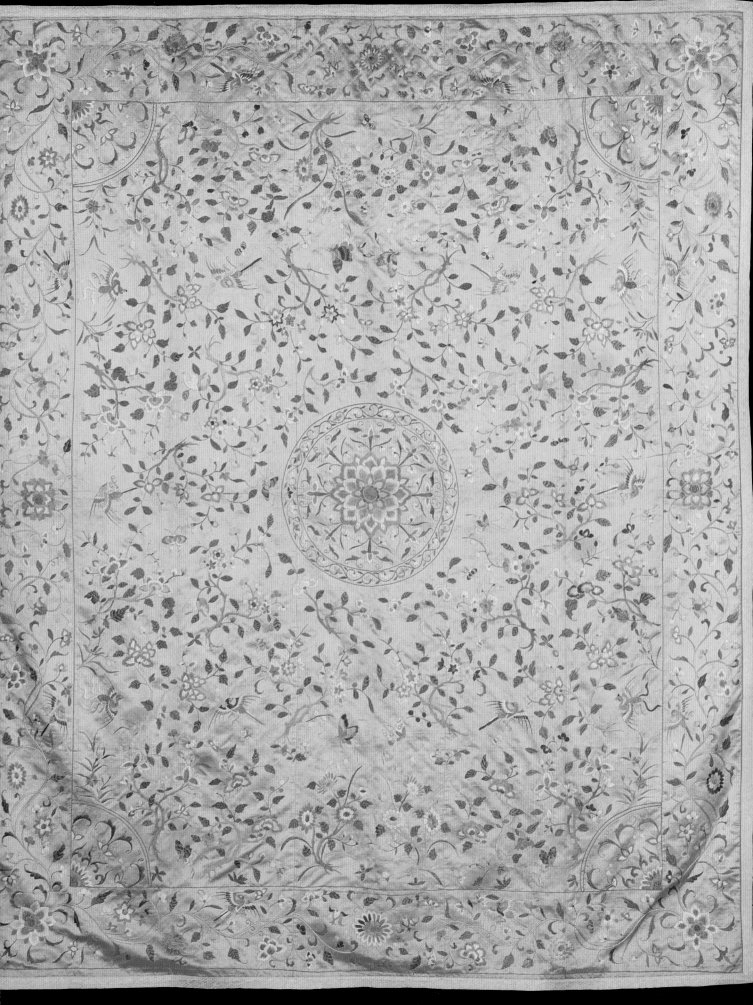

the addition of a cartouche of European blue velvet, which is early eighteenth-century in style and was probably therefore added not long after the set's arrival at the Duke's mansion at Cannons, north of London. It serves to give emphasis to the coat of arms. No other textiles from Canton show this feature. The Chandos motto has also worn away with time, suggesting the presence of an iron content in the black thread in which it was embroidered.

The relatively small size of the trade in finished textiles means it is very unlikely that any embroidery workshop in the eighteenth century existed solely to produce items for western customers. The bedspreads which were exported from as early as the late seventeenth century were hence not surprisingly related, at least in the beginning, to quilt covers used in the domestic market. However, the large meandering floral motifs disposed about a central roundel, which cover a large area with relatively little effort, are distinctively export-orientated, differing as they do from the much denser, symmetrical decorative schemes seen on pieces in the taste of Chinese customers. The embroidery is carried out in soft floats of untwisted embroidery silk, mainly in satin stitch. Women, men and boys all worked in professional embroidery workshops, at silk held under tension by a frame.

The colours on this otherwise well-preserved bedspread were originally considerably brighter, and are used in an almost random fashion, with more than one colour being used for the petals of a single flower. This piece currently lacks the fringes, often of European manufacture, which survive on other known examples. The bedspread was, prior to its acquisition by the Museum, the property of the King family of Madingley Hall, near Cambridge. In the eighteenth century the house was the home of the Cotton family, at least one member of which, Admiral Sir Charles Cotton (1753–1812), visited the Far East, in 1770–1772.

Silks decorated by painting were imported to England and elsewhere as both dress and furnishing fabrics. A surprisingly large amount of this material survives unused (7). This may be due to the lack of correlation between the length and width of the pieces and the quantity needed for bed-hangings or for items of dress cut to designs which the Chinese suppliers would not necessarily ever have seen. It may also have something to do with the inherent impracticality and lack of durability of material decorated in this way, which was, it should be remembered, invariably purchased by men though largely destined for use by women. The rhythms imposed on trade with East Asia by the winds and seas prevented these painted textiles from taking a place at the cutting edge of European fashion. The length of voyages meant that decoration could not be altered quickly enough to keep up with the dictates of the most advanced western styles. They were rather perennial favourites throughout the late eighteenth and early nineteenth centuries, valued for their prettiness, exoticism and relative cheapness, with the added advantage over their rivals, the printed and painted cottons imported from India, that they possessed the 'rustle' which was a desired part of the total presentation of a woman of fashion.

The painting of furnishing or dress material for export on silk of gauze, plain or satin weave does not appear to be in any direct line of descent from the Chinese high art tradition of painting on silk. In any case, by the eighteenth century that tradition had declined, with the majority of artists in the prestigious 'scholar' tradition choosing to work on the more absorbent medium of paper. However at

7
LOOM WIDTH OF
PAINTED SILK
About 1770
84 × 76 cm
T.121-1933
Deedes Gift

least one of the technical processes involved was the same in that, following dyeing, the silk had to be sized. This was usually done with alum. In the case of painted export silks, an ink outline for the design was then laid down, either by free-hand painting, or perhaps by pressing a heavily inked paper drawing on to the surface, in a technique also known to have been used in export painting on paper. There is no evidence that the technique of woodblock printing was used in Canton to prepare these textiles, and indeed the mere fact of a pattern having a near-exact repeat does not preclude the use of free-hand drawing. The colour decoration was washed on, not always carefully, within this outline. A coat of lead, or sometimes chalk, white was usually applied first to add body and lustre to the pigments, themselves a mix of organic and inorganic colours. Finally, the colour was outlined with a painted line of gold or silver, now generally tarnished. While this may allude to the practice, common in Chinese embroidery, of outlining motifs with couched gold thread, it may equally reflect a persistent strand in items produced for Europeans, where the heavy use of gold-painted lacquer and gilt enamelling on porcelain suggests a prevailing aesthetic of 'glitter'.

In addition to uncut furnishing and dress fabrics, westerners in Canton occasionally bought items of clothing for personal use. However, one of the largest bodies of finished dress items exported from Canton as a speculative commercial venture in the eighteenth century took the form of religious vestments. China was a major source of silk vestments, made out of painted and embroidered fabrics as well as from those self-patterned on the loom, for the large Catholic communities of the Spanish Americas as far north as California, and it was perhaps for them, rather than for the tiny body of Christians within China itself, that a set of vestments such as those shown (*8, 9*) may have been decorated. Vestments destined for the Americas were shipped through Manila in the Philippines, and the possibility exists that some silks woven in China were actually painted there. The chasuble shown is formed from one loom width of cream satin-weave silk, painted with the addition of a metallic outline to the lavish floral decoration. The painted decoration was clearly executed after the piece was cut to shape. The painted borders imitate European applied trimmings, while the floral decoration, which unusually appears to be devoid of any Christian symbolic content, is a hybrid, exotically foreign to western as well as Chinese eyes.

The fashion for painted silks imported from China declined from the beginning of the nineteenth century, perhaps in the face of a battery of new textile decorating techniques developed by European entrepreneurs. The burgeoning of European silk industries, and their rapid mechanization, also eroded any price advantage which the cheapness of Chinese labour gave to its products on western markets. However, a specialized category of textiles which began to be made for export around 1820, and which has been more or less uninterruptedly in production throughout the nineteenth and twentieth centuries to the present day, is embroidered shawls (*10, 11*). In the nineteenth century the ground for these highly decorated items was silk, although synthetic fabrics competed from the 1920s, if not earlier. Similar shawls were woven and embroidered in Spain and in the Philippines (a Spanish possession until 1898), the closeness in general design being such that it is occasionally impossible to tell the products of the various centres apart. The square shawl is not a part of the Chinese dress tradition, the shape being dictated purely by the needs of European fashion, where they were

8 (*right*)
CHASUBLE
Painted silk
About 1780
Height 107 cm
T.89-1923

9 (*overleaf*)
STOLE, MANIPLE,
CHALICE VEIL AND
BURSE
From a set of vestments
Painted silk
About 1780
Length of stole 239.6 cm
T.90, 91, 92, 93-1923

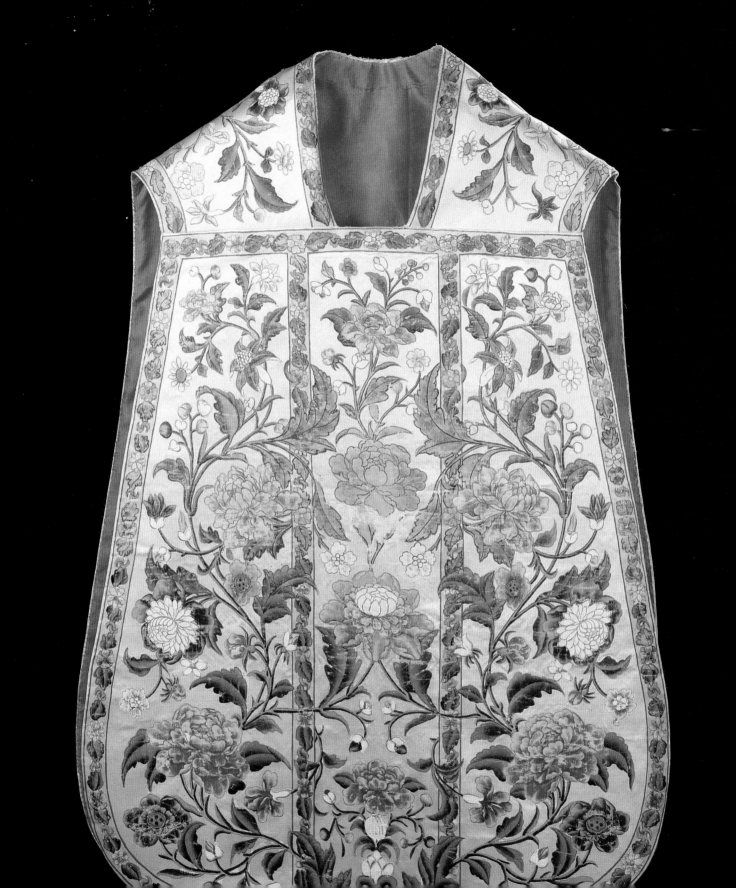

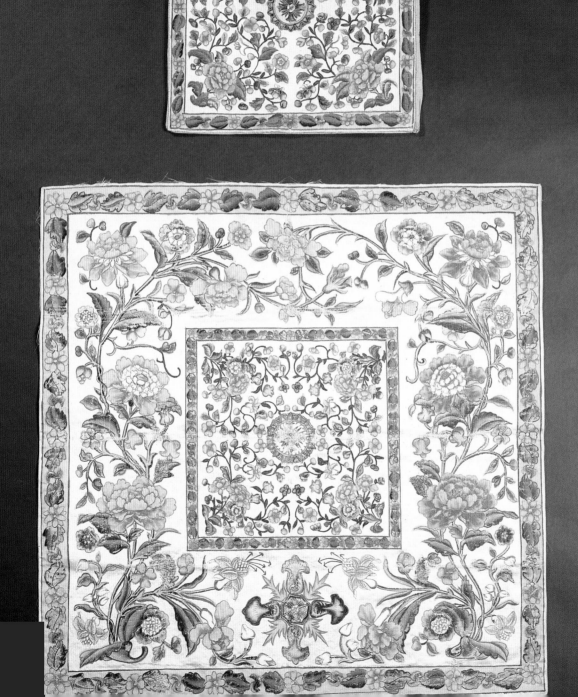

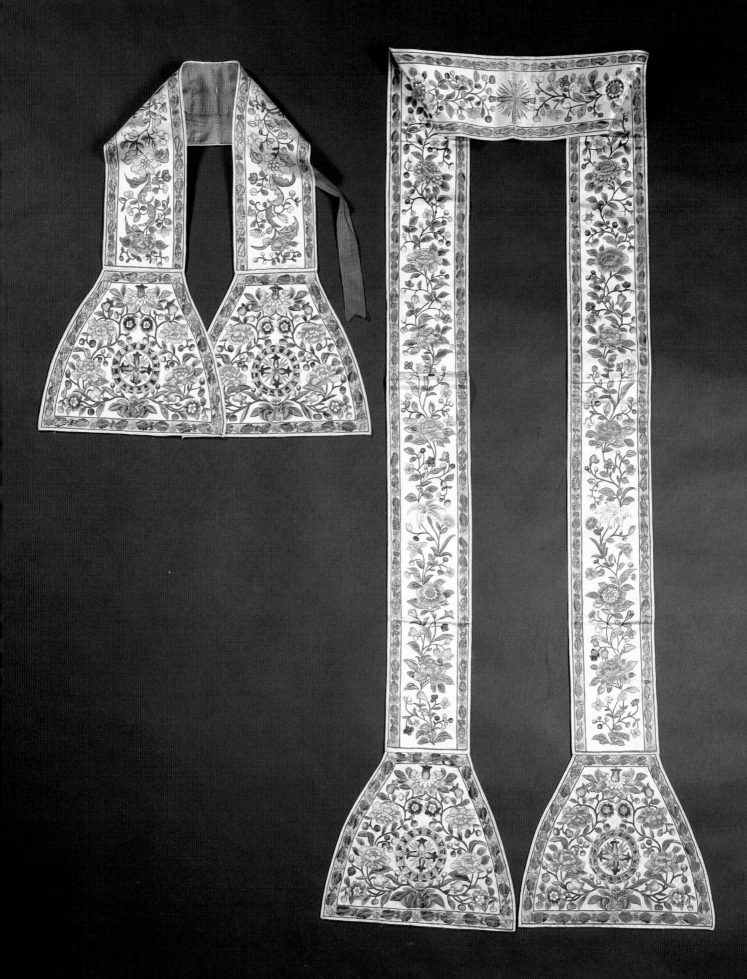

both items of clothing and features in interior decoration, being draped over tables and pianos as well as being pinned on walls. In the 1820s and 1830s they remained on the level of occasional souvenirs, but following the war of 1840–1842, an industry developed in the Canton area devoted to their manufacture. One observer writing in 1875 noted that the silk (usually a silk crêpe in a plain weave) was manufactured away from Canton, and brought there to have the outlines of the design drawn onto the surface, either free-hand or by the use of a pounced pattern, where chalk dust was pressed through the holes in a prepared paper stencil. They were then sent further down the coast to be actually embroidered by both men and women. The workshops where the shawl silk was woven must have had specialized weavers to set up the very wide looms needed to produce the roughly square pieces without seaming the material. The existence of this very self-contained nexus of economic interests, which had little or no involvement in the domestic silk market but was dedicated to export production, and hence highly vulnerable to fluctuations of demand in the West, is symptomatic of the increasing subordination of sectors of the Canton region's economy to foreign interests.

In Victorian and Edwardian Britain, these fringed shawls held appeal for their supposedly 'arty', somewhat bohemian associations rather than as components in the fashion mainstream. Examples of the type were displayed, and highly praised by the judges, in the Great Exhibition of 1851. They figure prominently in Liberty's first catalogue of 1881, where a flamboyant bi-coloured example such as the illustrated piece (*11*) would have fallen into the category of 'art colours'. Also on offer were 'plain Canton crape shawls', suggesting that there may also have been a trade in unembroidered examples. However all of these seem to have had the distinctive deep silk fringe. This kind of knotted edging is an element drawn from the Chinese textile tradition, being found both on wall-hangings and on women's sleeveless coats.

The bi-coloured shawl, embroidered with typically fanciful flowers, allows the wearer the choice of ground colour, being reddish-orange on the side shown but yellow on the other half of the square. By contrast, a shawl on a white ground embroidered with flowers and figure subjects (*10*) has a much more contained design, and displays a very natural way to dispose the pattern on a garment designed to be folded diagonally, with a border framing four smaller diamond shapes.

In the later part of the nineteenth century, importers such as Liberty's also brought to England quantities of clothes in the Chinese tradition, principally ladies' robes, which were worn as evening coats by European ladies, and as dressing gowns by both men and women. This trade has been more or less continuous since then, but received a boost in the 1920s, when changing social mores within China put on the market large numbers of garments in styles which were no longer current under the new Republic, such as the 'dragon robes' worn by government functionaries. Demand for these items remains sufficient to sustain a small industry, based in the silk producing centre of Suzhou, manufacturing imitations of Qing dynasty garments for the tourist and export markets. VW

10 (*top*)
SHAWL
Silk crêpe decorated with silk embroidery
About 1830–1860
160 × 160 cm (excluding fringe)
T.8-1936
Given by Queen Mary

11 (*bottom*)
SHAWL
Silk crêpe decorated with silk embroidery
About 1870–1920
170.8 × 167 cm (excluding fringe)
T.316-1960
Baldry Gift

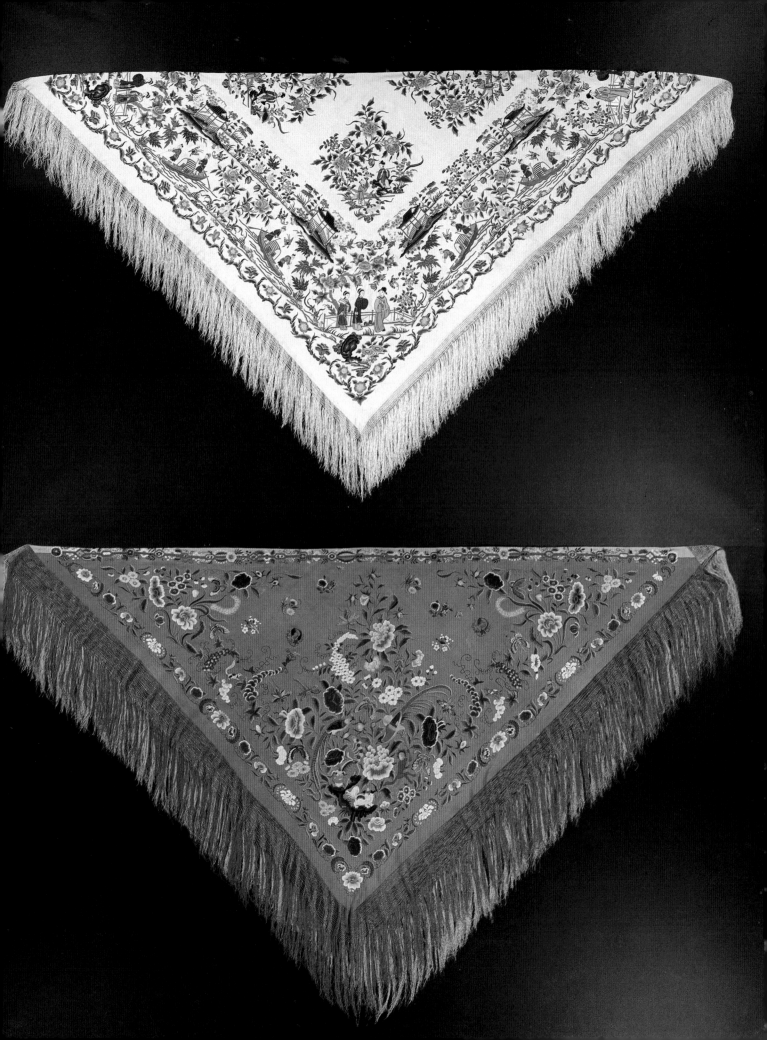

Early Export Ceramics

ONE reason why Chinese ceramics found such a ready market abroad is that many were made of the thin, white, translucent material which we call porcelain. Porcelain is composed of a mixture of crushed rock (porcelain stone) and clay (china clay, or kaolin). Porcelain was produced in China as early as the ninth century, about a thousand years before it was made in Europe. Its association with East Asia is so close that the other name for the material is 'china'.

Most Chinese porcelain was mass-produced in factories at the town of Jingdezhen in southern central China. Jingdezhen had exported porcelains to other countries as early as the tenth century. However, the trade to Europe before about 1600 was sporadic, and many pieces only found their way out as individual seamen's cargo. This was probably the case with the mounted ewer (12), for it bears the coat of arms of a man who was known to have been on a trading mission to China in the late sixteenth century. Certain identification of the arms is impossible without the tinctures, but it is likely that they are those of the Portuguese family of Peixoto. Antonio Peixoto, together with his partners Antonio da Mota and Francisco Zeimoto, sailed round the China coast in a junk laden with hides and other commodities. Having unsuccessfully tried to enter Canton, they went on to Quanzhou where they transacted their business at sea. If the porcelain ewers (there is at least one other identical piece known) were purchased on this trip, it may be that they were mounted on the return journey, or very soon afterwards, for the silver mounts are contemporary.

After 1600 Dutch merchants established more regular trading links. Some of the mainly blue-and-white porcelain they bought was trans-shipped to England and sold on the London market. This practice is illustrated by the Chinese jar and cover (13), which was given elaborate silver gilt mounts and a handle to transform it into a lidded tankard.

The tall jar (14) is a pot for drugs, made in China for the European market around 1650. Tall pots to contain spices, herbs and medicinal syrups were first used in Persia and Syria between about 1175 and 1250. From about 1400 copies were made at kilns in Spain, and subsequently in Italy. The Italian name *albarello* is often used for the jars, a word that itself may go back to the Arabic *al barani*, a general term for storage containers. *Albarelli* became popular items across Europe between 1500 and 1750, and were made in many places. In spite of this, it was economic for the Dutch East India Company to import large numbers of medicine jars from China between 1600 and 1700. The most usual forms were tall with concave sides, or small and round (the ovoid gallipot). Rounded, waisted jars like this example are quite rare, and only four are known to exist today. The other three have near-identical decoration save for their labels, and the four may originally have formed all or part of a set.

12 (*right*)
EWER WITH PERSIAN
SILVER MOUNTS
Porcelain with decoration in underglaze blue
Probably arms of the Peixoto family
Mark and reign period of Jiajing (1522–1566)
Height 33 cm
C.222-1931
Gulland Bequest

13 (*overleaf left*)
TANKARD WITH
ENGLISH SILVER GILT
MOUNTS
Porcelain with decoration in underglaze blue
London hall-mark on the mount
About 1630–1645
Height 18.5 cm
C.577-1910
Salting Bequest

14 (*overleaf right*)
DRUG JAR
Porcelain with decoration in underglaze blue
Winged cherub heads among flowers
About 1660–1680
Height 23.5 cm
C.70-1963
Basil Ionides Bequest

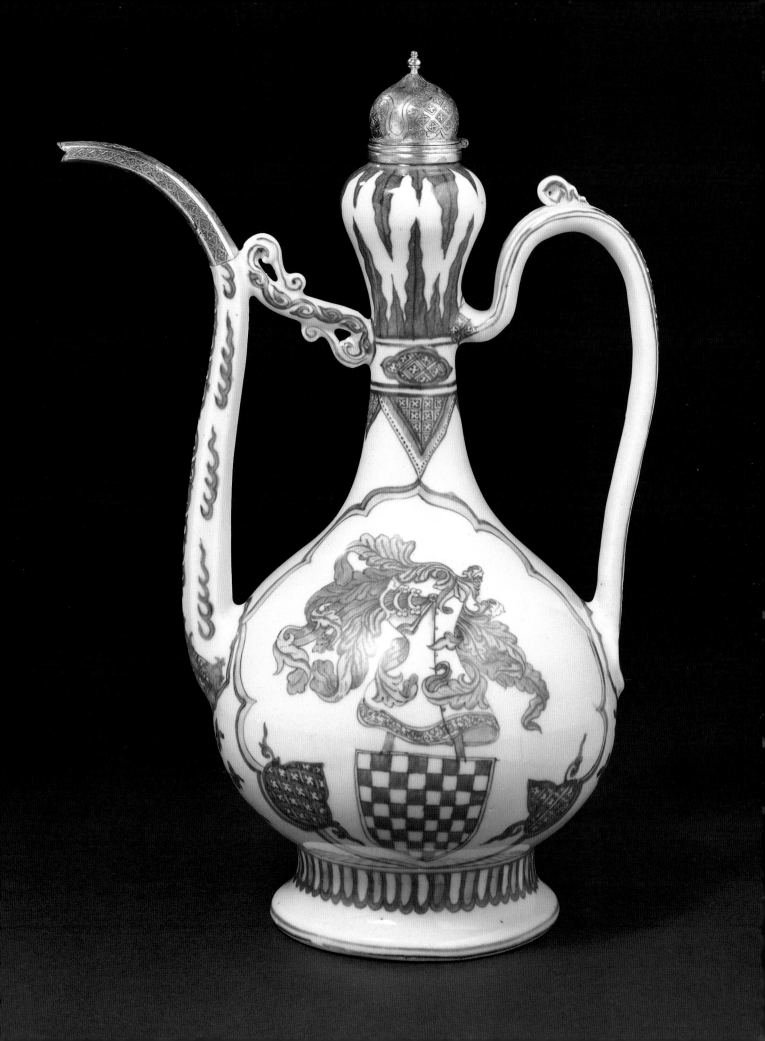

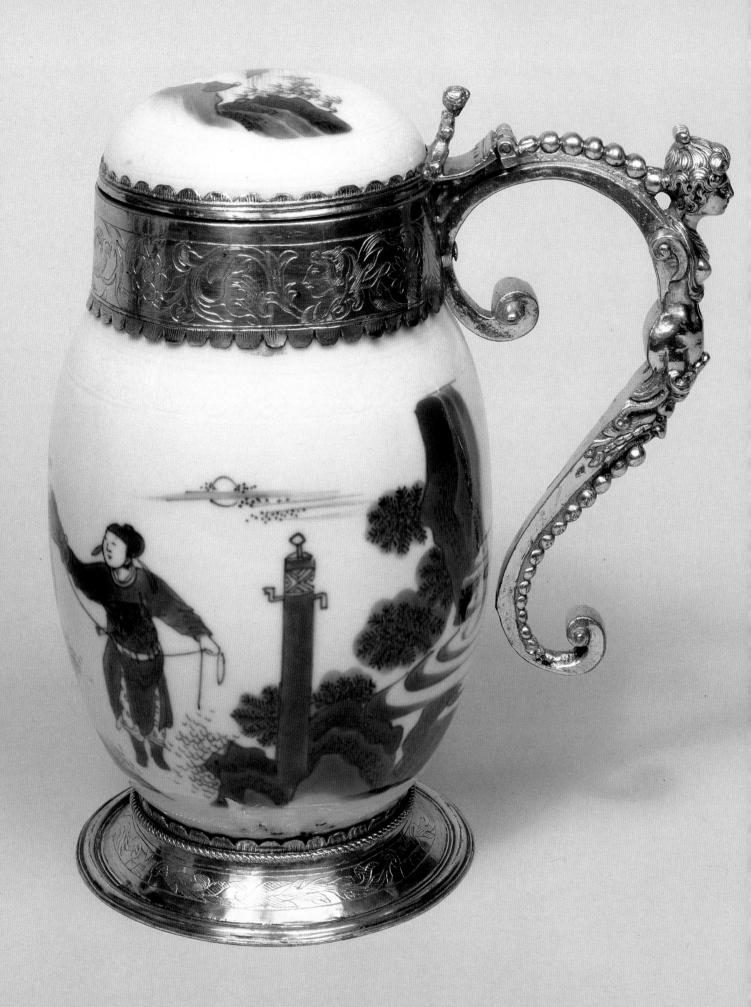

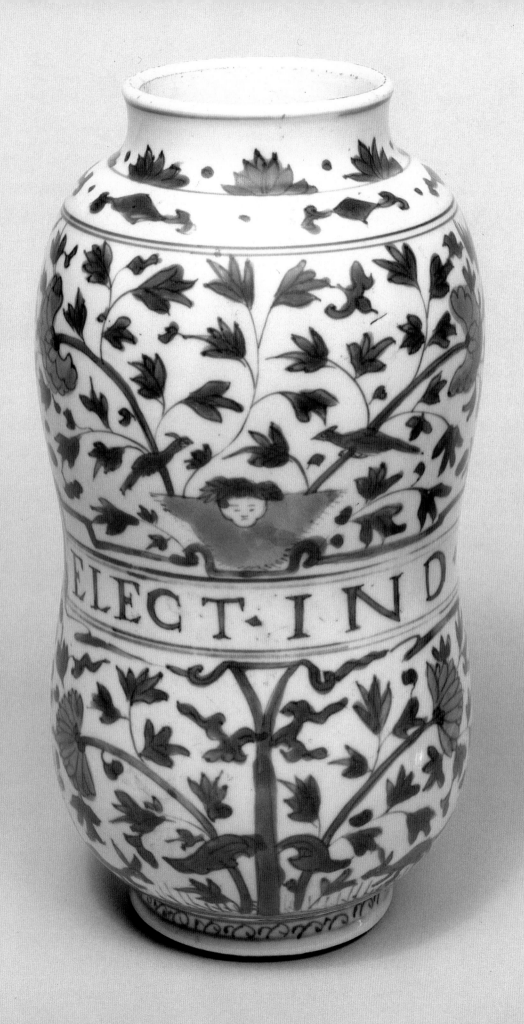

The pattern of winged cherub heads among flower scrolls with birds and animals was used on Italian drug jars between about 1500 and 1600. However, Italian painters themselves made use of elements they saw on imported Chinese ceramics and textiles. The flowers were originally meant to be peonies, and the pattern band on the shoulder was a further Chinese contribution. The label on the drug jar reads ELECT. IND., an abbreviation for *Electuarium Indum majus*. This was a strong laxative medicine made from crushed turpeth root, scammony, cardamom seeds, cinnamon and other ingredients, mixed with honey as a sweetener.

Of all designs on export porcelain, the most popular was that on pieces known to Europeans as 'Kraak ware'. The word *kraak* is Dutch, and is believed to be either a corruption of the name for a Portuguese carrack, a type of cargo ship used in Asian waters, or to represent the chimney embrasure shelves on which porcelain was displayed in European homes. The Kraak wares were generally of rather inferior manufacture. A typical pattern consisted of a central picture surrounded by panelled designs radiating towards the rim. This design started around 1575 and continued in favour until about 1650. Later pieces can show western influence, like a dish (*16*) which shows tulips drawn in a European manner in the border. Shown beside the dish is a vase (*15*) of typical seventeenth-century cylindrical form, described in contemporary Dutch records as *rolwagen*. The lucky animals and plants on this *rolwagen* are purely Chinese decorative themes.

The years surrounding the fall of the Ming dynasty in 1644 and the founding of the new Qing dynasty were uncertain, and foreign trade suffered. However the second Qing emperor Kangxi (1662–1722) was vigorous and reforming, and during his reign China's industries and exports boomed. Some of the best blue-and-white porcelain was made at this time, and the garniture (*17*) is characteristic of the export style. Vases and jars in these shapes were made for Chinese temples, but their combination in sets of four to nine pieces satisfied western requirements. Europeans used the sets as display pieces, and they were commonly set on the mantelpiece or on furniture placed against the walls of a room. Other favoured spots were the fireplace in summer, beneath cabinets and tables at floor level, or at the top of the staircase.

By 1700 the taste for blue-and-white was declining in favour of more colourfully-decorated porcelain. One of the Chinese responses was to imitate a style made popular by Japanese exporters, the so-called 'Imari ware'. Imari, which was the Japanese port from which porcelain was shipped, gave its name to pieces decorated in a combination of underglaze cobalt blue with overglaze iron red enamel and gilding. The magnificent container (*18*) is an example of 'Chinese Imari', and consists of a large jar and cover mounted in gilt bronze to form an urn.

Chinese potters soon discovered that it was quicker to decorate coloured wares entirely in enamels, like the dish shown here (*19*). The tones used on the dish include soft pink, a colour derived from gold and believed to have been introduced into China from Europe around 1720. Many of the other pigments are muted by the addition of opaque white enamel, another new invention. The design of a basket of flowers had been popular with porcelain decorators for more than a hundred years. The bold style of drawing, and the bright colours used, suggest that the motif may have been influenced by popular painting, or paper-cuts. The carp swimming among weed, painted on the rim, was another prevalent theme in folk art. RK

15 (*left*)
VASE
Porcelain with decoration in underglaze blue
Magical creatures phoenix and *qilin*, with insects and flowers
About 1630–1645
Height 46.5 cm
C.419-1926
Burman Bequest

16 (*right*)
DISH
Porcelain with decoration in underglaze blue
Figures and flowers
About 1635–1655
Diameter 47.5 cm
C.457-1918
Vacher Gift

17 (*overleaf*)
GARNITURE OF FOUR VASES
Porcelain with decoration in underglaze blue
Ladies and tubs of flowers
About 1700–1720
Maximum height 46.5 cm
C.843, 844, 845, 846-1910
Salting Bequest

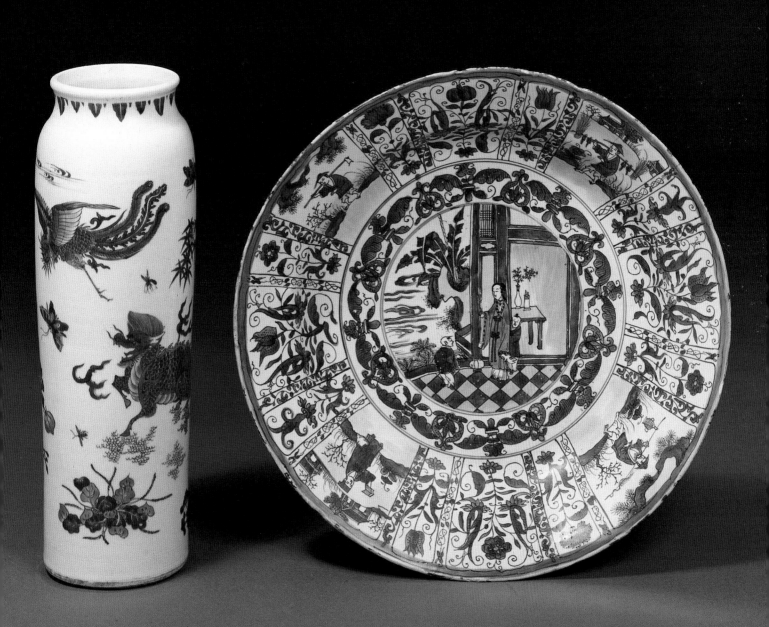

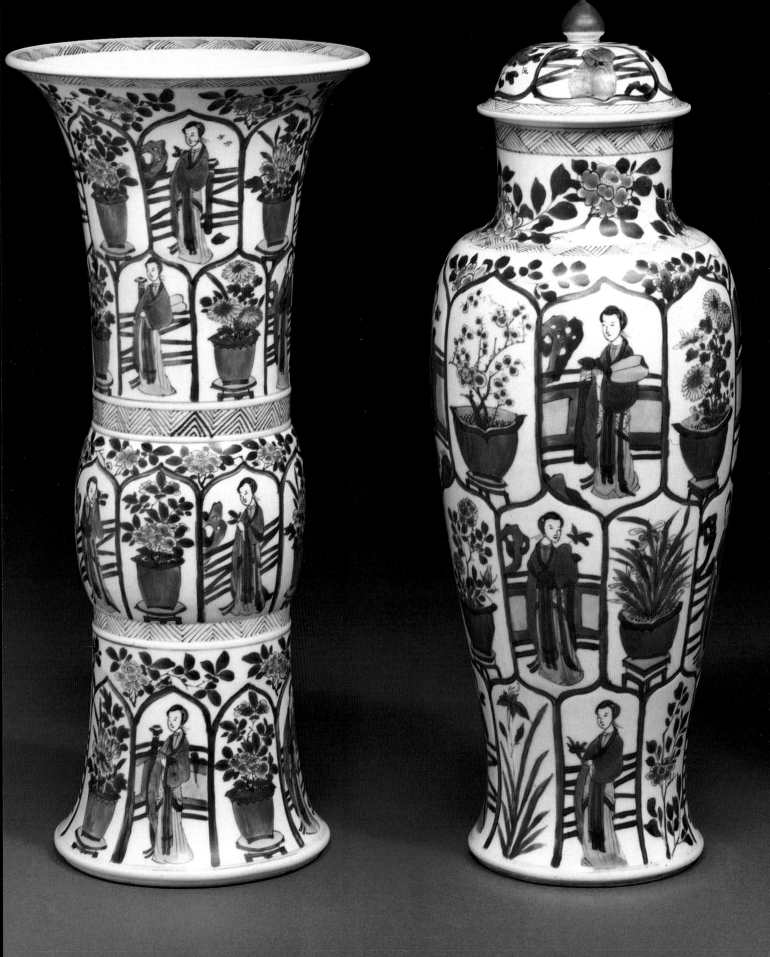

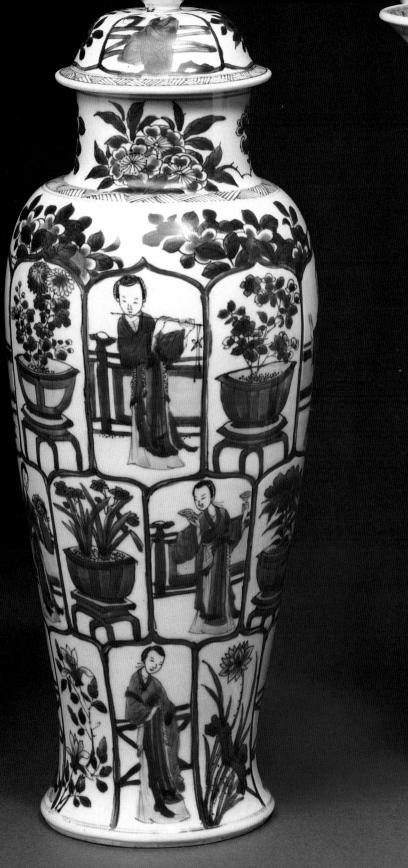
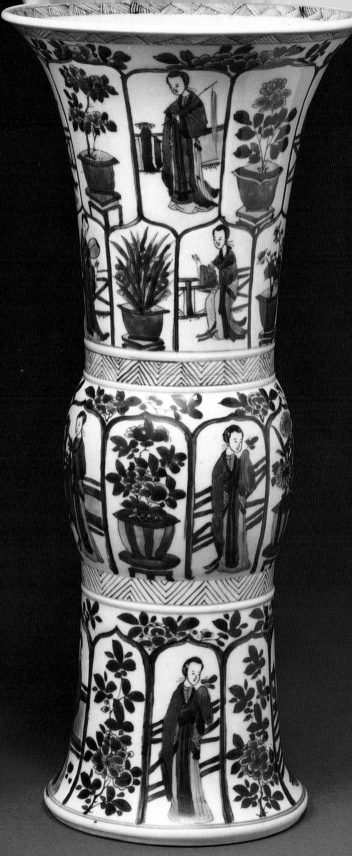

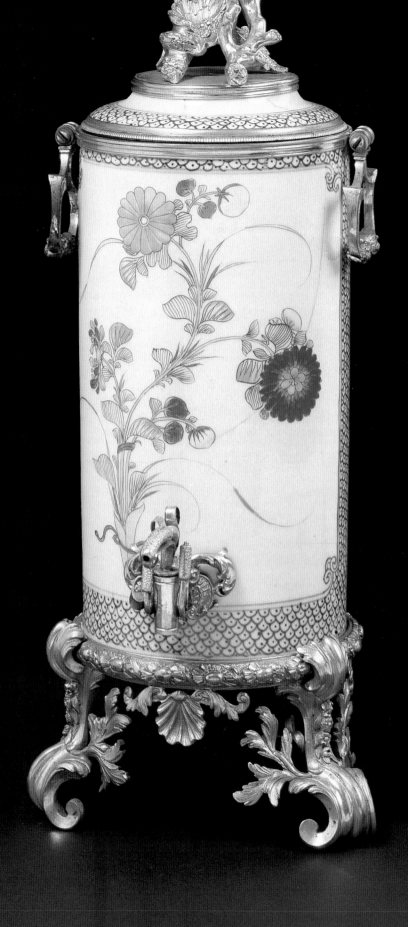

GILT BRONZE MOUNTS
Porcelain with decoration in
underglaze blue, overglaze enamel
and gilt
Chrysanthemums
About 1710–1730
Height 33.5 cm
166-1879

19 (*right*)
DISH
Porcelain with decoration in
overglaze enamels and gilt
Basket of flowers, and swimming
carp
About 1740–1750
Diameter 38.7 cm
C.1391-1910
Salting Bequest

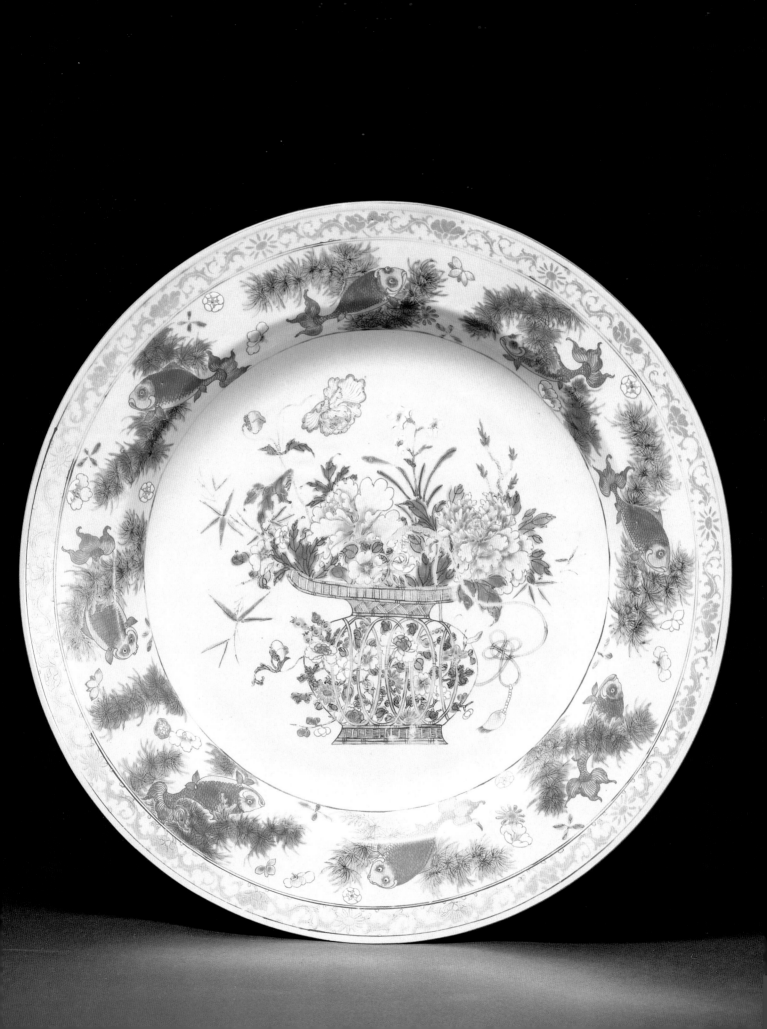

Ceramics Exported in Bulk

Y 1700 the British had cornered an equal share in the Chinese export market with the Dutch, and by 1730 they had attained trade supremacy. Initially porcelain had been used as a flooring for other more pricey and delicate cargos, but from about 1725 onwards it became a valuable commodity in its own right. The demand for Chinese ceramics remained high until the 1770s, when British orders started to decrease. By then, English ceramics were of higher quality, were produced in greater numbers and were marketed in a more aggressive fashion. By 1810 less than five thousand pieces of foreign porcelain were being imported into England each year. It was not until the 1880s that significant numbers of Chinese ceramics started to appear on the London market again. However, these were individual ornaments for the home and garden, not bulk tableware.

During the boom years of the mid eighteenth century, several hundred thousand pieces of Chinese porcelain were being shipped every year, both by public companies and as private merchant cargo. Some of these were individual orders, others were blank pieces to be decorated in Europe, but by far the greatest number were mass-produced items decorated in China with standard patterns. Some of the principal styles are discussd below.

The Imari style was popular in both England and Holland and has already been mentioned (p.38). The vase (*20*) was decorated with several colours in addition to the standard red and blue. Its double-gourd shape was traditional in China, but the manner of painting followed Japanese examples more closely than most 'Chinese Imaris'.

Although less desirable than coloured wares, blue-and-white porcelain continued to be manufactured in bulk, for it was both easier to make and cheaper to buy. The pieces grouped together (*21–26*) represent some of the most common types. The dish at the top left (*21*) is sparsely decorated with peony, rock and bamboo, and was presumably one of the most inexpensive patterns. It is painted with standard motifs that could be reproduced in a matter of minutes. The cup and saucer (*23*), lidded tureen (*26*) and jug (*24*) bear variations on a Chinese river landscape with pavilions, bridges and small boats. This formulaic scene had evolved through centuries of stylised landscape depiction, and its conventions would have been instantly understood by any Chinese. Europeans, on the other hand, found the design exotic and transformed it into the fairytale 'willow pattern'. The dish at the top left of the group (*21*) has a pseudo-Chinese version of the scene, probably copied from English transfer-printed ware. This re-copying of western *chinoiserie* in China became more common as patterns were sent from Europe. The man who painted this dish may not even have recognised the landscape he was reproducing as Chinese.

20

VASE IN DOUBLE-GOURD FORM
Decorated after a Japanese style with underglaze blue, overglaze enamels, and gilding
Plum blossom, chrysanthemum, iris and peony
About 1720–1740
Height 38 cm
C.1501-1910
Salting Bequest

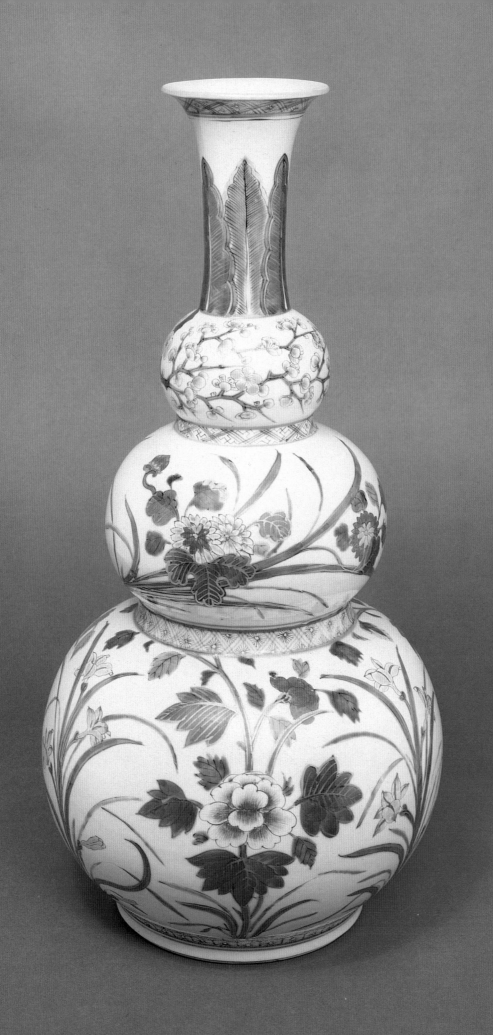

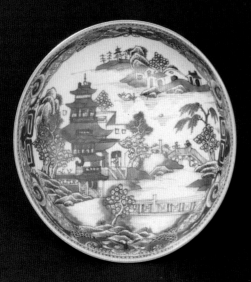

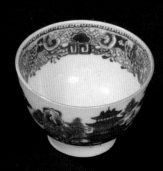

21 (top left)
SOUP DISH
Porcelain with decoration in
underglaze blue
Peony, rock and bamboo
About 1730–1740
Diameter 23 cm
FE.15-1977
Miss Dorothy B. Simpson Bequest

22 (right)
DISH
Porcelain with decoration in
underglaze blue
River landscape, copied from
English transfer-printed ware
About 1785–1795
Diameter 20.3 cm
402-1903
Woodcroft Bequest

23 (bottom left)
CUP AND SAUCER
Porcelain with decoration in
underglaze blue
River landscape
About 1770
Diameter of saucer 12.7 cm
FE.28-1977
Miss Dorothy B. Simpson Bequest

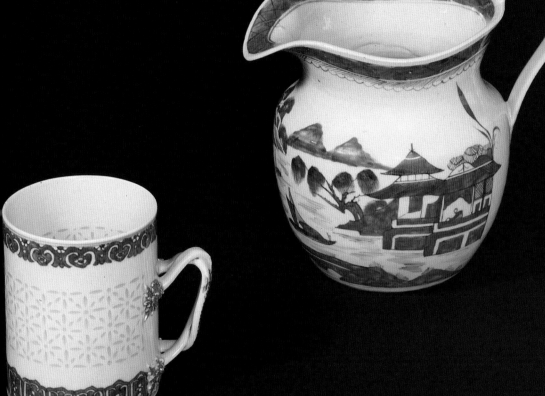

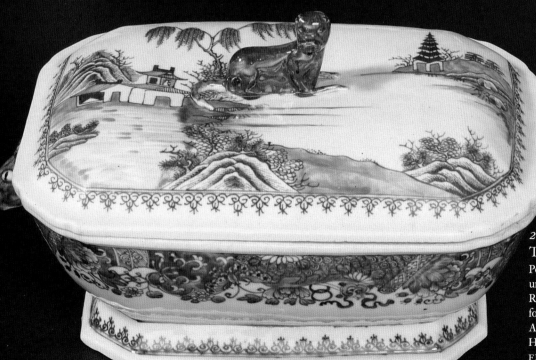

24 (*top*)
JUG
Porcelain with decoration in
underglaze blue
River landscape
About 1800–1820
Height 25 cm
FE.35-1977
Miss Dorothy B. Simpson
Bequest

25 (*centre*)
MUG
Porcelain with incised and
underglaze blue decoration
So-called 'rice grain pattern'
About 1790–1810
Height 14 cm
461-1892

26 (*bottom*)
TUREEN AND COVER
Porcelain with decoration in
underglaze blue
River landscape, with knop in
form of a dog
About 1770
Height 26 cm
FE.36-1973
Miss Lettice Digby Bequest

The mug (*25*) is decorated with what we know as the 'rice grain pattern'. Legend still holds that the design was produced by imbedding grains of rice in unfired porcelain, but the truth is more prosaic. Small incisions were made when the pot was leather-hard. It was then dipped in glaze many times, to ensure that the mixture penetrated every crevice. When fired, the glaze-filled holes appear transparent. This mug has a European shape, as do the jug and tureen.

Two vessels painted with colours are shown (*27, 28*). Such enamelled pieces had to be fired twice, a longer process that increased their cost. The first high-temperature firing was carried out in a large kiln to bake the porcelain body. The second low-temperature firing was done in a small stove to fix the enamel colours (metallic pigments suspended in lead glaze). The enamelled barber's bowl shown here (*27*), while very obviously a western form, is decorated with Chinese themes. Two men sit on a mat playing *weiqi*, a game using black and white counters on a squared board, whose object is to surround the opponent's pieces so that he cannot move. The semicircular gap in the rim of the bowl served to tuck into the crook of the barber's arm, or under the client's chin, while he was being shaved.

The hexagonal teapot (*28*) is constructed in an elaborate manner using open-work panels and applied flower sprays. The Chinese employed ceramic pots for wine long before they used them for tea. It is likely that containers with handles and spouts were first introduced for tea when methods of preparing the liquid changed. In early times powdered tea was mixed with boiling water in the drinking bowl itself. During the fourteenth century whole dried leaves of tea began to be used, and these needed to be steeped for a while in hot water to release their flavour.

In addition to vessels made of porcelain, Europeans also favoured figurines. The Chinese had been constructing ceramic models of humans and animals in moulds since at least the third century BC. However, these figures were almost always for use in tombs, or as religious images. Thus figurines for ornamental use often showed western influence, as is the case with the pair of King Charles spaniels (*29*), which were based on European models. This breed, which is believed to have been imported from East Asia, first became popular in England during the seventeenth century.

The pair of elegant ladies with movable heads (*30*) are of exceptional quality. In general, figures of women were popular because they portrayed the exotic features and dress styles of the Orient. These two have elaborate hairstyles and beautiful faces, and are robed in brocaded surcoats over long panelled skirts; the details of rich silken cloth are skilfully suggested. In one hand they carry objects shaped like branches of fungus, known in Chinese as *ruyi*. *Ruyi* literally means 'as you wish', and these items, in porcelain, hardstone or wood, were given as tokens of friendship and warm wishes. In symbolic terms they represented good fortune.

By contrast, the plain white figure (*32*) was a religious image, the Buddhist deity Guanyin. Guanyin was a Bodhisattva, in other words a being who was holy enough to enter paradise, but who had chosen to remain on earth to help mortals. Guanyin was the patron of fishermen, and for that reason she is shown above waves with a pair of sea dragons. She was also prayed to by women as the 'bringer of sons', and here she has a baby on her lap, and two other small boys in attitudes

27 (left)
BARBER'S BOWL
Porcelain with decoration in overglaze enamels
Gentlemen playing a board game outdoors
About 1720–1740
Width 31 cm
Circ.42-1932
Gulland Bequest

28 (right)
TEAPOT
Porcelain with decoration in overglaze enamels
Relief openwork panels and painted flowers
About 1730–1750
Height 12 cm
610-1903
Cope Bequest

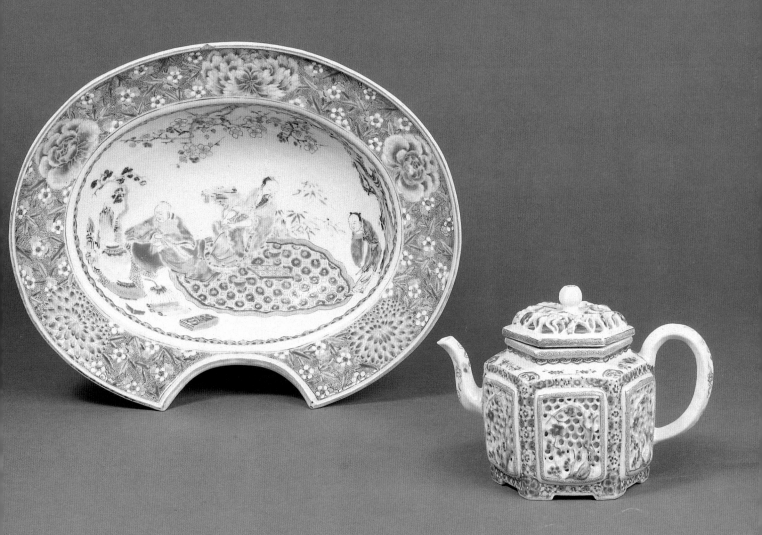

29 (left)
PAIR OF KING CHARLES
SPANIELS
Porcelain with decoration in
overglaze enamels
About 1750–1770
Height 16.7 cm
FE.5-1978
Gift of C. N. Ades, in memory of
his wife Andrée

30 (right)
PAIR OF LADIES WITH
MOVEABLE HEADS
Porcelain with decoration in
overglaze enamels
About 1740–1760
Height 40.5 cm
FE.18-1978
Gift of C. N. Ades, in memory of
his wife Andrée

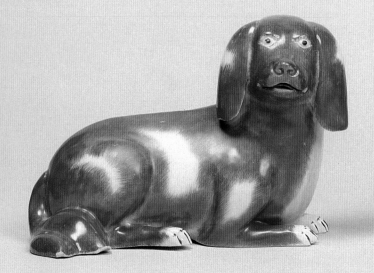
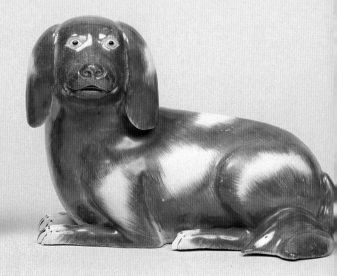

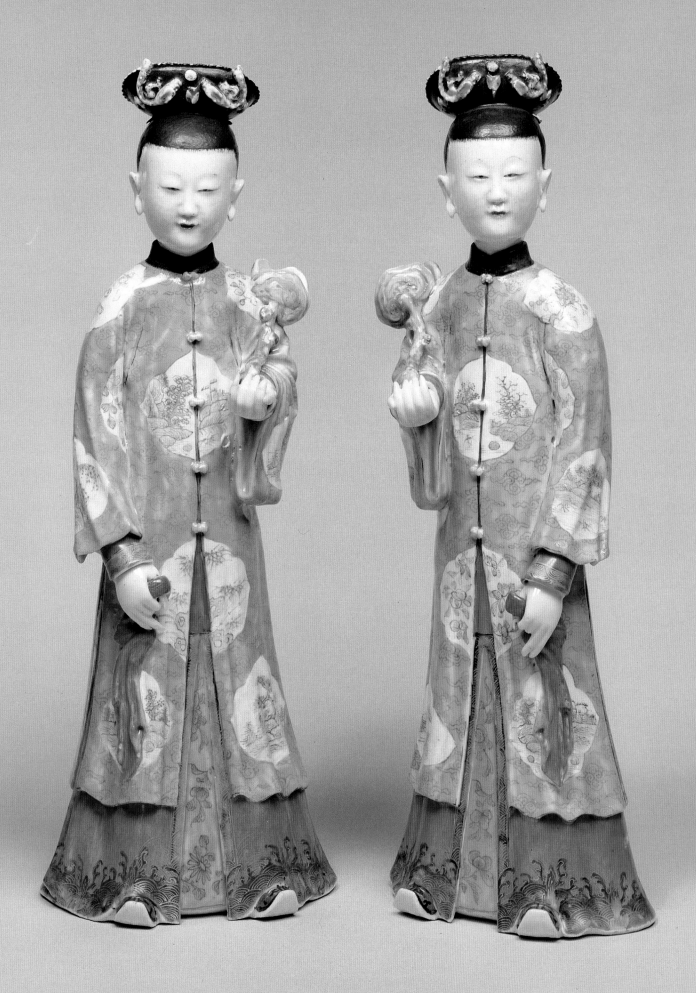

31 (*top left*)
CUP
Porcelain with moulded decoration
of plum blossom
Dehua ware
About 1620–1720
Height 8.5 cm
C.95-1956
Tulk Bequest

32 (*top right*)
THE COMPASSIONATE BODHISATTVA GUANYIN
In her aspect as 'the bringer of
sons' with small boys, and with sea
dragons
Moulded white porcelain
Dehua ware
About 1620–1720
Height 38 cm
19-1886

33 (*bottom left*)
HEXAGONAL TEAPOT
Red stoneware with
press-moulded decoration
Yixing ware
About 1675–1725
Height 10.5 cm
C.27-1947

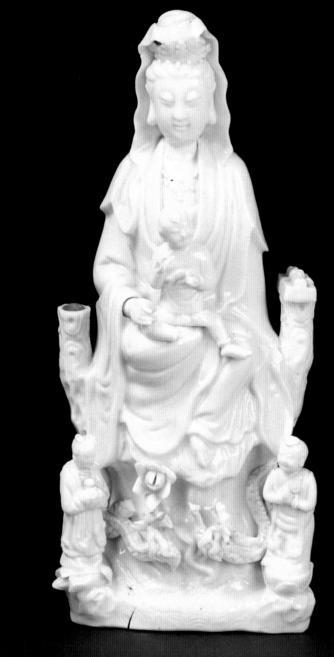

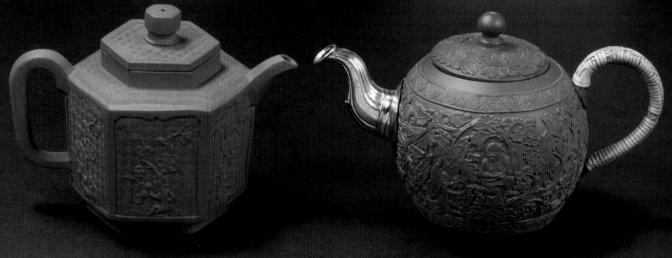

34 *(opposite bottom right)*

TEAPOT

Red stoneware with replacement
silver spout and wicker
handle
Moulded design of small boys
among peony stems
Yixing ware
About 1675–1725
Height 10.8 cm
729-1853

35 *(below)*

DISH

Porcelain decorated in Canton
with overglaze enamels and
gilding
Birds, butterflies and flowers
About 1820–1850
Diameter 36 cm
708-1852

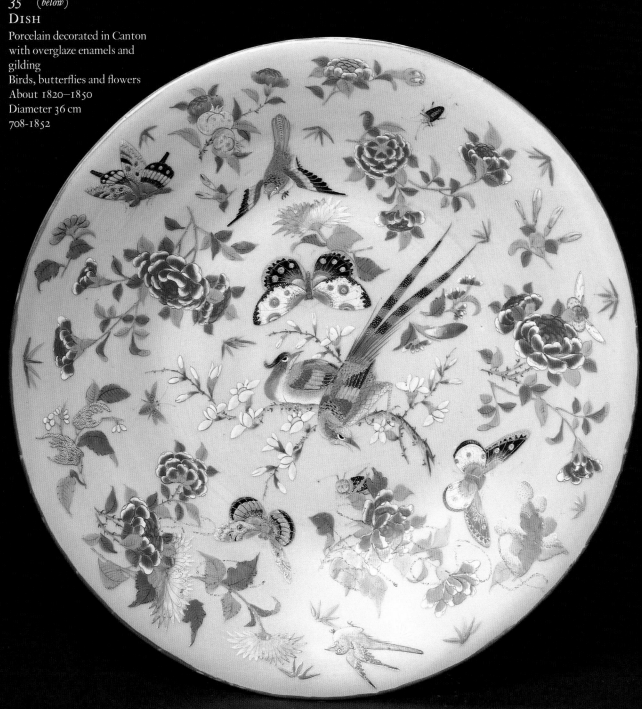

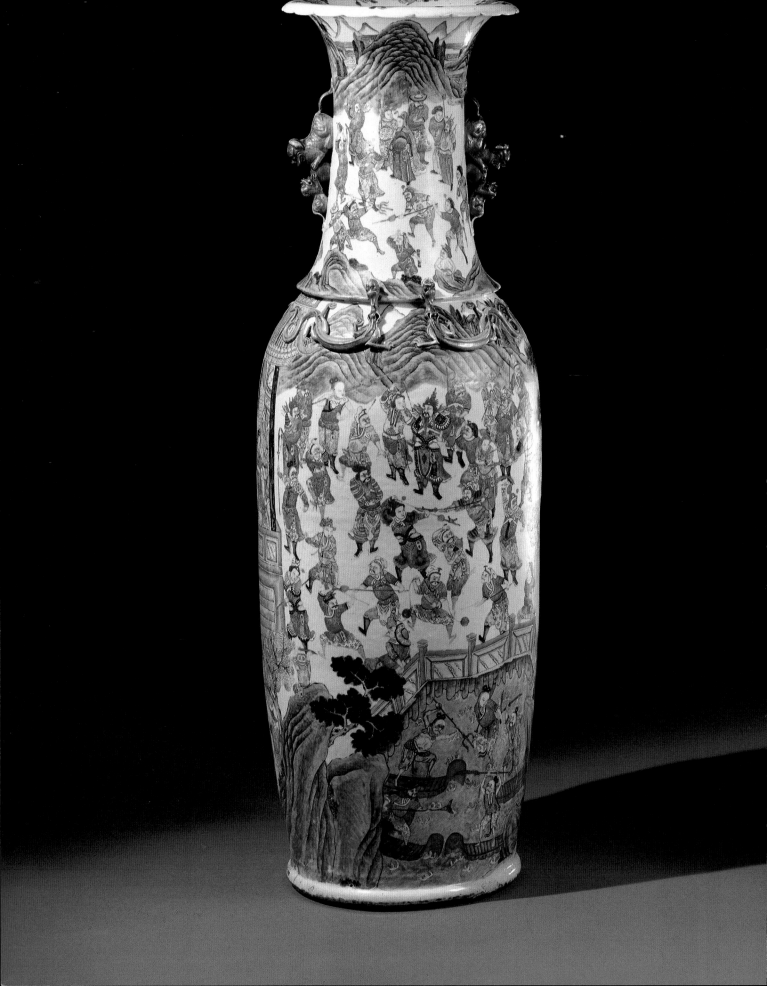

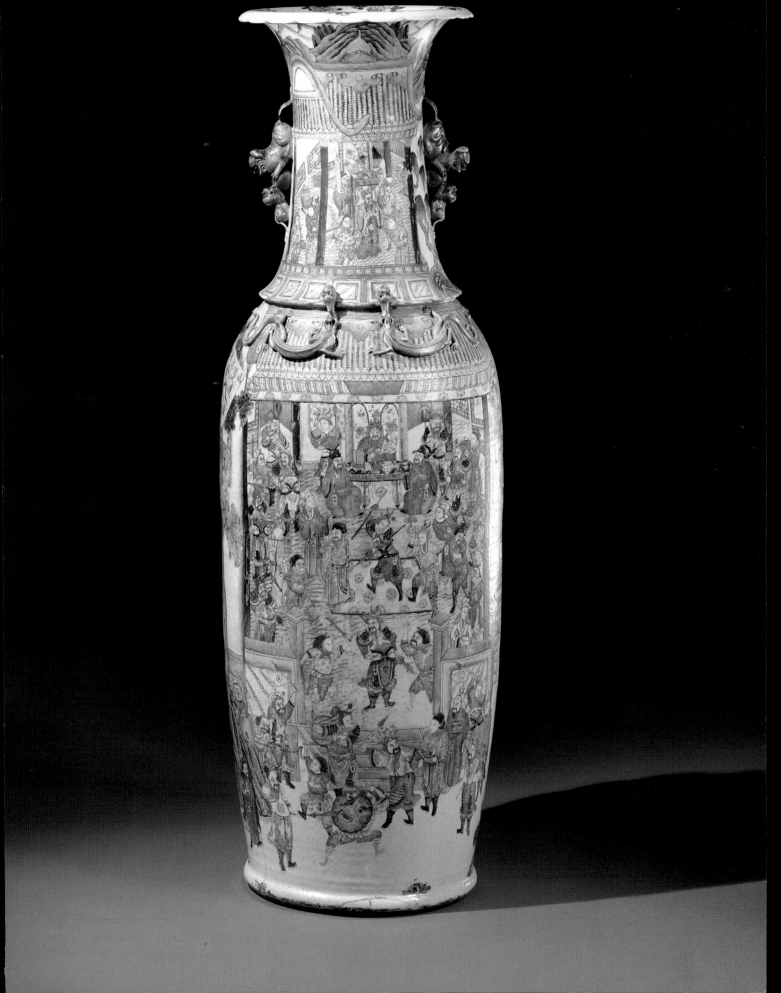

of devotion by her throne. Similar figure groups had entered collections in Europe by the late seventeenth century.

Both Guanyin and the little prunus cup (*31*) beside her were made in a different place from the other porcelain illustrated in this book. They came from kilns near the town of Dehua in the south-eastern coastal province of Fujian. This sort of ware became known as '*blanc de Chine*' in the West, and although the proportion of export pieces coming from Dehua was small, it was much admired. Examples like the prunus cup were copied at several European factories.

The two teapots made of red stoneware (*33, 34*) originated from a third area, that of Yixing in Jiangsu province. The Yixing kilns had long specialised in the manufacture of tea wares, for the clay there was particularly suitable for that purpose. A dense ceramic body kept the liquid warm, and was not unpleasantly hot to the touch, like thin porcelain. Yixing wares were first seen in Europe in the mid seventeenth century, and were immediately imitated. Examples like the hexagonal pot with panels of prunus on a ground of square spirals (*33*), whose shape derived from metal, lent both their form and their decoration to western crafts. The other teapot (*34*) is decorated with small boys among scrolling peonies, a traditional Chinese design which was reproduced in every detail at Staffordshire in the mid eighteenth century.

After 1800 the pace of the China trade slowed, and there were consequently fewer distinctive types of export ware. One is that shown by the green dish painted with butterflies, a late example of coloured ware (*35*). Pieces decorated in Canton with a lavish palette of colours had been popular in England, and even more so in France, from the later eighteenth century. Huge 'mandarin' vases as big as five feet high were made to be viewed at a distance, on a staircase or in a lighted niche (*36*). Seen at close range the decoration seems coarse, for it was not intended for detailed inspection. The taste for this '*grand mandarin ancien*' continued unabated into the nineteenth century, and many houses still contain large display pieces in this style.

The vase with crackled glaze (*38*) copies a bronze shape, and the unglazed brown portions simulate metal. These rather crude wares survive in great numbers, and are often decorated with figures in blue or in coloured enamels. They almost always bear the mark of the emperor Chenghua (1465–1487) in a brown square on the base, but are of much later date. In fact, it is interesting that this example was acquired by the Museum as early as 1876.

The broader market for Chinese crafts in the late nineteenth century was aided by firms like Liberty's. Their 1881 catalogue shows pots with the same dragon design as that on three 'pen holders', acquired by the V&A in 1893 (*37*). The pattern came in various sizes, the largest of which were umbrella stands two feet high and costing seventy shillings each. By 1891 Liberty's were importing sufficient quantities to warrant a price reduction to fifty shillings. RK

36 (*previous pages*)
VASE
Porcelain decorated in Canton with overglaze enamels and gilding
Scenes from the novel *The Water Margin*, with applied lions and dragons
About 1840–1850
Height 152 cm
666-1883

37 (*left*)
THREE VASES, FOR USE AS PEN HOLDERS
Porcelain with decoration in enamels
Dragons among flowers
About 1880–1890
Heights 21.5, 22.5, 23.5 cm
11, 11A, 11B-1893

38 (*right*)
VASE
Porcelain with crackled glazes and simulated metal mounts
About 1865–1875
Height 28.5 cm
21-1876

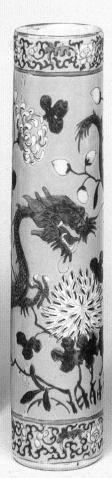

Ceramics Made to Special Order

OST porcelain imported by the companies took the form of bulk items of a uniform shape and pattern, but items brought back as private trade were more often than not specially commissioned made either by officers and supercargoes on their own account, or on behalf of individuals and dealers in Europe. Popular designs of the day, like engravings, book illustrations, and even drawings were sent out to China for copying, as well as models showing the shapes required. Some of the earliest and most numerous of such pieces were services decorated with armorial bearings, but as the eighteenth century progressed, there was hardly a European subject or design that did not appear on, or shape that was not modelled in, Chinese porcelain.

Many of the early special orders are only recognisable by their shape or, decoratively, by a small cartouche containing a western design. Even by the early 1700s, this was still the case. The dish on the cover of this book is only recognisable as a commission by the central design of a lady and two gentlemen making music. Likewise the monteith, or glass chiller (39), only betrays its European source by its shape. The decoration consists of standard Chinese patterns and motifs of the Kangxi period (1662–1722), and owes nothing to any European influences. The monteith as a vessel is thought to have been invented some time in the early 1680s and is supposedly named after a Scot of that name who wore a cloak with U-shaped notches at the hem. It seems likely that this Chinese example was copied from either a silver or Delft original.

The tulip vase (41) and coffee pot (40), though contemporary with the monteith, have both shape and decoration taken directly from Delft originals. The tulip vase is most likely copied from a design by Adriaen Kocks. Built pyramidically, the vase divides into two sections, stabilised by a wooden dowel which runs through the centre. The original model for the coffee pot was probably made by Lambert van Eenhoorn. As the hexagonal shape would suggest, the prototype would have been of silver or pewter. The underglaze blue decoration consists of figures in a landscape below a decorative border in which a figure group appears, probably representing Europa and the Bull.

Some of the earliest pieces to be made to order in any great quantity were those decorated with coats of arms. At first these were ordered by families connected in some way with the East India Company, but it was not long before most of the great families of Britain, and some of Europe, were ordering anything from single dishes to large dinner services decorated with their own coats of arms. An early armorial plate in the collection is illustrated in (42). Very flat in shape, the rim is decorated in a typical Chinese fashion of the Kangxi period (1662–1722), while the centre of the dish reveals an as yet unidentified armorial device. This relatively simple piece, which would have been decorated as well as made at the porcelain town of Jingdezhen, is in stark contrast to an elaborate and finely painted

39
MONTEITH OR GLASS
CHILLER
Porcelain with decoration in
underglaze blue
About 1700–1715
Diameter 31.7 cm
564-1907

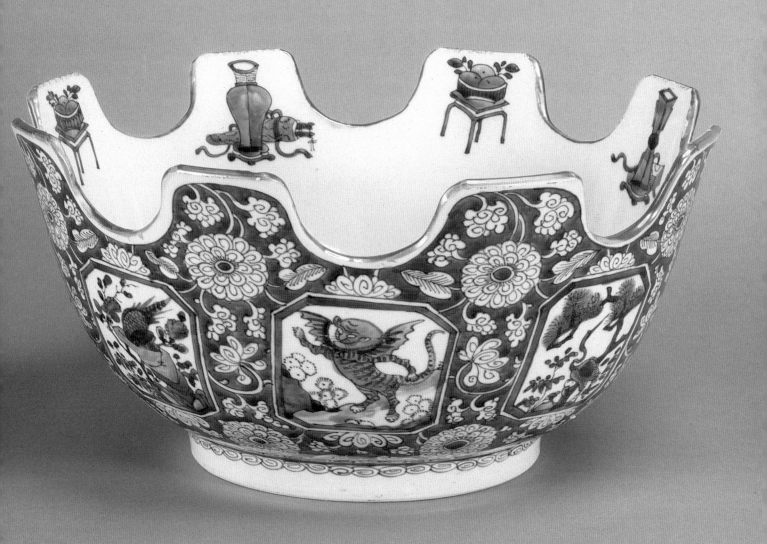

dish (43), made in about 1740 for Leake Okeover Esq. The documents which accompanied the shipment reveal that the original service consisted of 120 plates and 34 dishes, each item costing the sum of £1. It displays the full panoply of colours that were available to the Chinese decorator by this time. All the colours were applied over the glaze, and almost certainly the work was carried out at Canton where enamellers could more easily fulfil the various foreign requirements. Exactly when this began is difficult to ascertain. However, it seems probable that it started soon after the Europeans established a regular trade with China in the 1720s, and after enamel colours began to usurp the popularity of underglaze blue decoration in Europe, which occurred at roughly the same time. By the time of William Hickey's arrival in Canton in 1769, decorating workshops were commonplace. In his memoirs he wrote, 'We were shown the different processes used in finishing the chinaware. In one long gallery we found upwards of an hundred persons at work in sketching or finishing the various ornaments upon each particular piece of the ware, some parts being executed by men of a very advanced age, and others by children even so young as six or seven years.'

The fact that dinner services have survived in such large numbers indicates that they were a valued family possession. This view is reinforced by two dishes (44, 45). Part of a service originally made for William Jephson, a barrister of Lincoln's Inn, the first dish dates from about 1735. The second dish, however, is an English replacement made early in the nineteenth century, possibly at the Spode factory. While it was obviously important to replace any breakages in the service, by the nineteenth century it was no longer necessary to order porcelain from China.

40 (*left*)
COFFEE POT
Porcelain with decoration in underglaze blue
The original model was probably made by Lambert van Eenhoorn, at the Delft factory *De Metalen Pot* 1681–1721
About 1700–1720
Height 29.5 cm
C.71-1963
Basil Ionides Bequest.

41 (*right*)
VASE FOR TULIPS
Porcelain with decoration in underglaze blue
Probably copied from a design by Adriaen Kocks, who owned the *Grieksche A* Delft factory 1686–1701
About 1700
Height 36 cm
FE.3-1979

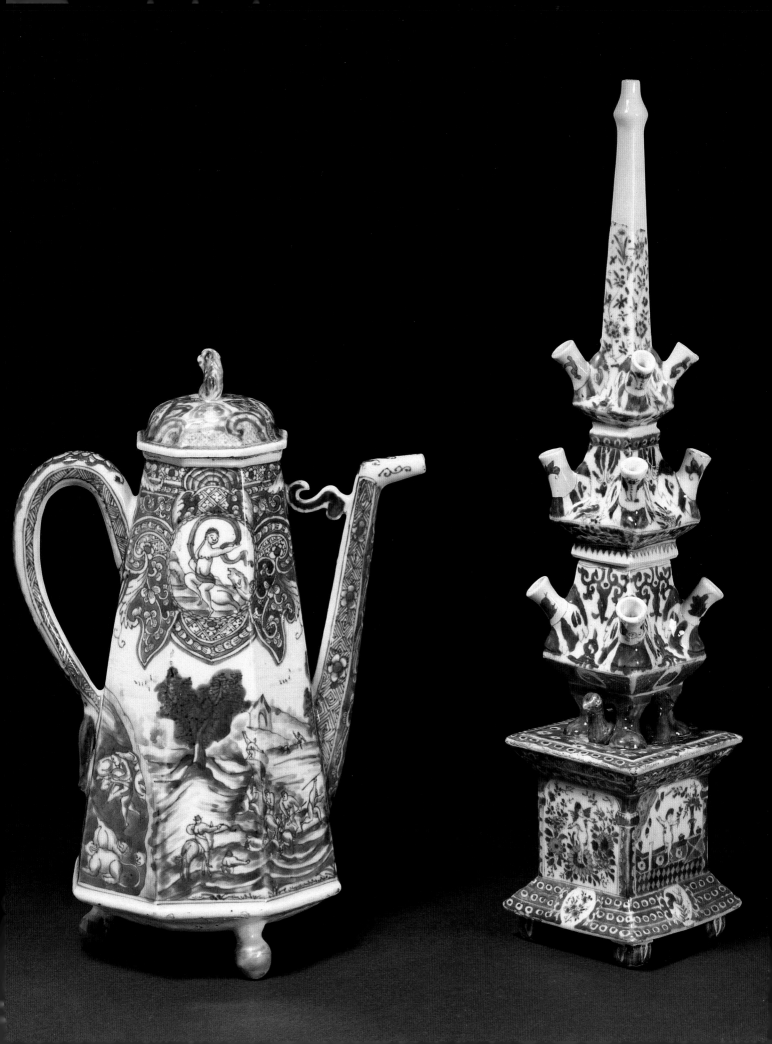

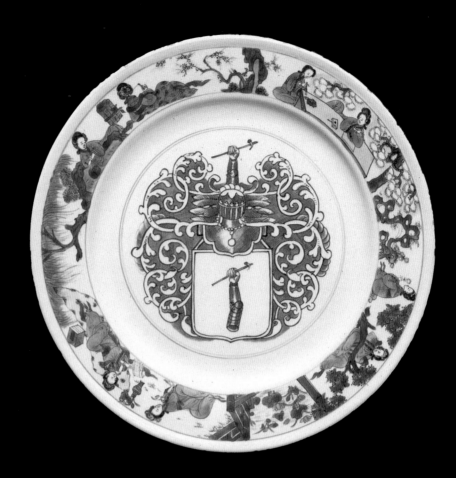

42 (*top*)
PLATE
Porcelain with decoration in
underglaze blue
Unidentified coat of arms
About 1700
Diameter 25 cm
C.68-1963
Basil Ionides Bequest

43 (*bottom*)
PLATE
Porcelain decorated in Canton
with overglaze enamels
Arms of Leake Okeover
About 1740–1743
Diameter 22.5 cm
FE.47-1982
Given by Mr and Mrs Peter
Rochelle-Thomas

Opposite page

44 (*top left*)
PLATE
Porcelain decorated in Canton
with overglaze enamels
Arms of William Jephson
About 1735
Diameter 24.7 cm
C.31-1951
Basil Ionides Bequest.

45 (*top right*)
PLATE
Porcelain with decoration in
overglaze enamels
Arms of William Jephson
ENGLISH, probably made at the
Spode factory
About 1810–1840
Diameter 24.7 cm
C.32-1951
Basil Ionides Bequest

46 (*bottom*)
DISH
Porcelain decorated in Canton
with overglaze enamels and gilding
Arms of Frederick the Great of
Prussia
About 1760
Diameter 26 cm
C.73-1963
Basil Ionides Bequest

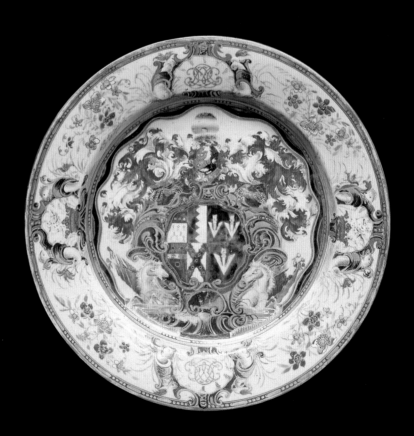

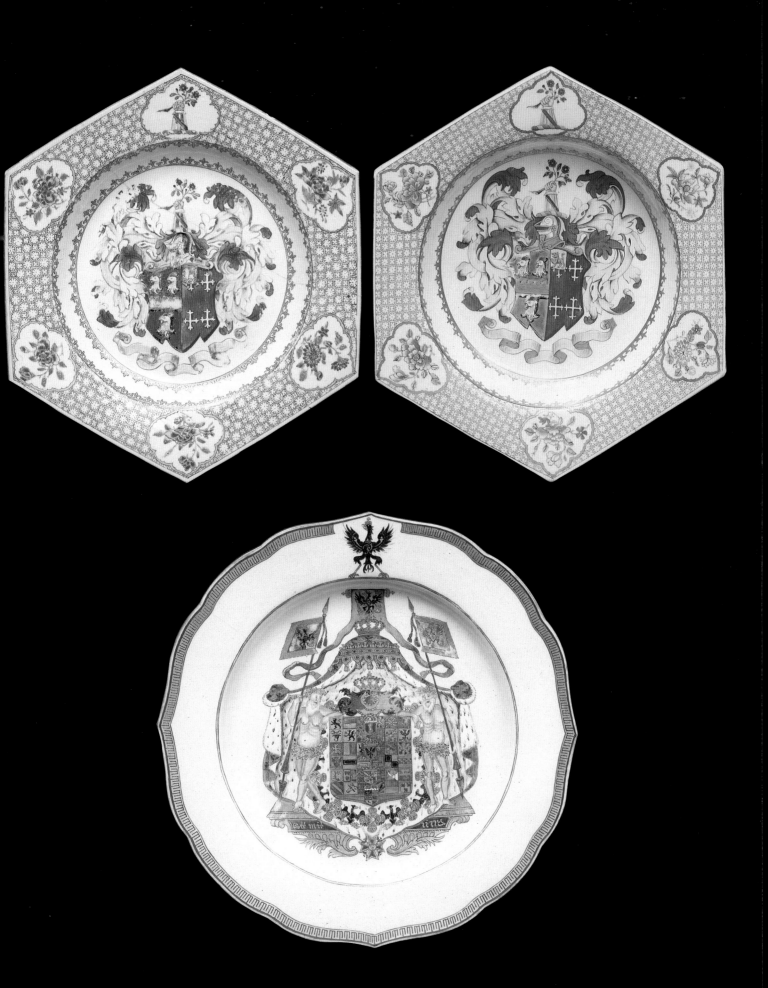

Another splendid example is a dish (*48*) with the armorial device of Frederick the Great of Prussia (1740–1786). History has it that a service was ordered as a gift for Frederick the Great by the Prussian Asiatic Company in 1753, but was mostly lost in a shipwreck off the coast of Emden in 1755. What survived of the service was auctioned in 1756. Is the dish part of that service? From a stylistic point of view, it would seem to post-date 1753, the black T-border on a gilt ground around the rim being reminiscent of European neo-classical designs of the 1760s and later. Other examples exist with the same coat of arms, but with a gilt lacework border on the rim in the style of Meissen, which would more easily be accepted as dating from the 1750s. The existence of more than one pattern strongly suggests that at least two, if not more, services existed at one time, made some eight or ten years apart. Perhaps another service was ordered for Frederick by the Prussian Asiatic Company before it ceased trading in 1763. Alternatively, it could have been made for British consumption. The Prussian King was extremely popular in Britain following the Seven Years War, both as hero and Freemason, as is evinced by his appearance in popular prints of the day, and also on commemorative ceramics right up until the end of the century.

In 1734, the Dutch East India Company commissioned the artist Cornelis Pronk (1691–1759) to provide a number of designs that would be suitable for copying onto porcelain. Between 1734 and 1737, Pronk provided at least three designs for the Company, two of the most famous being the so-called 'Parasol Ladies' and the 'Three Doctors'. The drawings for these two designs still survive. A design thought on stylistic grounds to be by Pronk (although no drawing survives) is that known as 'The Arbour' (*48*). However it is more likely that the decoration derives from a Meissen original of about 1725–1730 attributable to Martin Schnell. A number of Meissen bowls exist with this very design. The ladies in the arbour appear in the centre of both the Chinese dish and the Meissen bowl. The diaper pattern with reserved cartouches containing flowers and insects, which surrounds the outside of the bowl, has been used instead for the design of the well of the dish. Even the colours, a green arbour and turquoise diaper, are replicated. The expense of producing such elaborately decorated pieces soon convinced the Dutch Company to abandon the idea of commissioning special orders themselves, and they never did so again after 1740.

A large quantity of the porcelain shipped in bulk took the form of plain undecorated pieces. From evidence provided by Dutch East India Company records it seems that many of these were exported to the Netherlands so that the decoration could be applied there. The dish (*47*) would have been such a piece. Much Delft material was sent out to independent decorators, and it would have been one of these painters who applied the decoration to this piece. The design is taken from Peter Paul Rubens' painting, *Le Coup de Lance*. Commissioned in 1620, the painting now hangs in the Royal Museum of Fine Arts, Antwerp. The direct source for the porcelain decorator, however, was a line engraving of the painting by Boetius à Bolswert (about 1580–1634), who was probably a member of Rubens' workshop of engravers.

47 (*top*)
DISH
Porcelain with decoration in overglaze enamels applied in Holland
The Crucifixion, copied from an engraving by Boetius à Bolswert, after *Le Coup de Lance* by Rubens
About 1730
Diameter 21 cm
C.226-1931
Gulland Bequest

48 (*bottom*)
DISH
Porcelain with decoration in overglaze enamels
Probably copied from a Meissen original of about 1725–1730 attributable to Martin Schnell
About 1735–1740
Diameter 26.3 cm
Circ.452-1931
Gulland Bequest

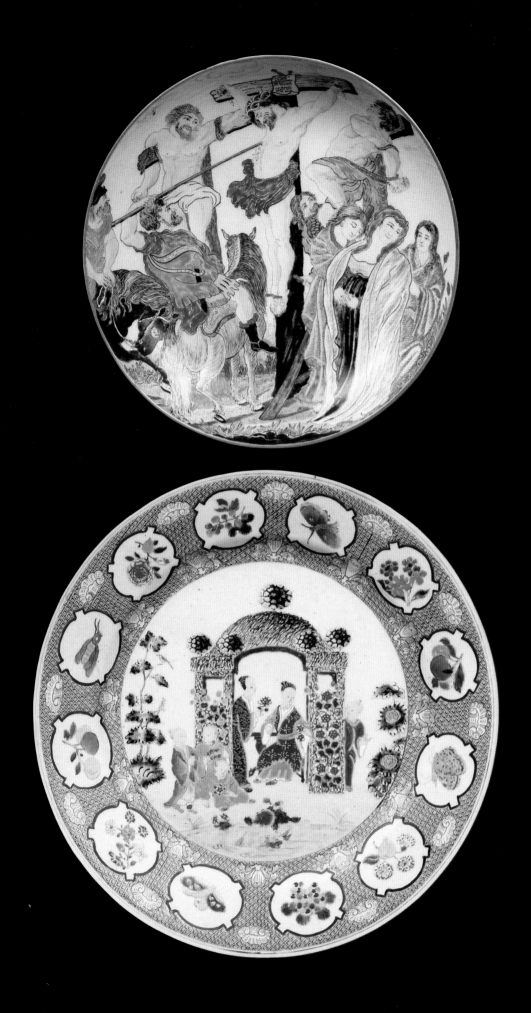

Services and individual items were sometimes commissioned in celebration of a wedding or similar occasion, such as the large dish (*49*). Decorated around the rim with gilding in the Meissen style, the centre of the dish is painted with a scene of a wedding couple being crowned beneath an archway by Juno, the goddess of marriage, with her peacock. She is accompanied by winged Iris and by Hymen, god of marriage, who holds a flaming torch. On the arch is inscribed: *Semper Amor Pro Te Firmissimus Atque Fidelis* ('Always my love for you both strong and true'), and on the columns flanking the arch are the arms of Nicolas Geelvinck and Johanna Graafland, who were married in 1729. Other examples from this service do survive, including another dish similar to the one illustrated and also in the Museum's collection (Circ.272-1931). The central design must have been a popular and lasting choice for celebrating a marriage, as similar dishes, but bearing different coats of arms, and of a much later date, are also known.

Decorative subject matter could be very wide-ranging, as the three pieces (*50, 51, 52*), show. The dish (*50*) is undoubtedly a masonic scene, and was probably commissioned by either an individual mason or by a lodge. The design shows three masters standing on a tessellated pavement consulting plans of a temple. Before them around the Ark, or repository box of the lodge, are the masons' tools: the gavel, square, compass, level and plum-rule. More numerous than masonic scenes were subjects from European mythology. Like religious subjects, they reached their height of propularity around 1750–60. The plate (*52*), decorated like that in (*49*) in black with flesh tints, illustrates the story of Mercury who appeared before Penelope in the form of a beautiful goat while she was tending her father's flocks in the mountains of Arcadia. Again it seems most likely that an engraving was the source. The final piece in this group (*51*) is an example of 'gallant', or slightly risqué decoration. Painted in enamels and surrounded by a gilt scroll border quartered by panels containing landscapes is the figure of a reclining nude. She is viewed, not without her encouragement, by a voyeur dressed like Harlequin. This kind of erotica is not unusual and is a feature common to the purely Chinese tradition, although the stark nakedness of this particular lady would not have been appreciated in China.

49

DISH

Porcelain with decoration in overglaze enamels and gilt
Allegorical wedding scene, with the arms of Geelvinck and Graafland
About 1730
Diameter 39.1 cm
C.215-1931
Gulland Bequest

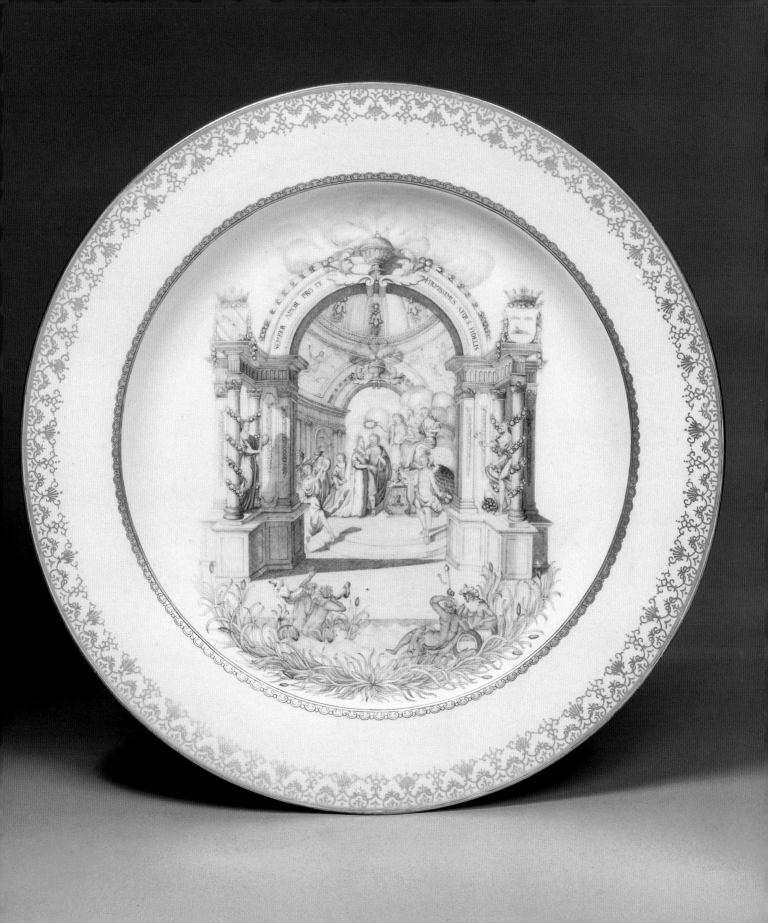

50 (left)
DISH
Porcelain decorated in Canton
with overglaze enamels
Three masters examining plans of a
masonic lodge, after an engraving
of 1755 by William Tringham
About 1760–1770
Diameter 21 cm
C.225-1931
Gulland Bequest

51 (centre)
DISH
Porcelain decorated in Canton
with overglaze enamels
A reclining nude and Harlequin
'peeping Tom'
About 1750
Diameter 20 cm
C.74-1963
Basil Ionides Bequest

52 (right)
DISH
Porcelain decorated in Canton
with overglaze enamels
Mercury disguised as a goat
approaching Penelope
About 1740–1750
Diameter 23 cm
C.80-1963
Basil Ionides Bequest

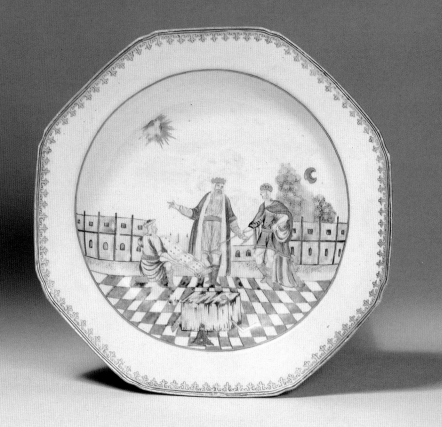

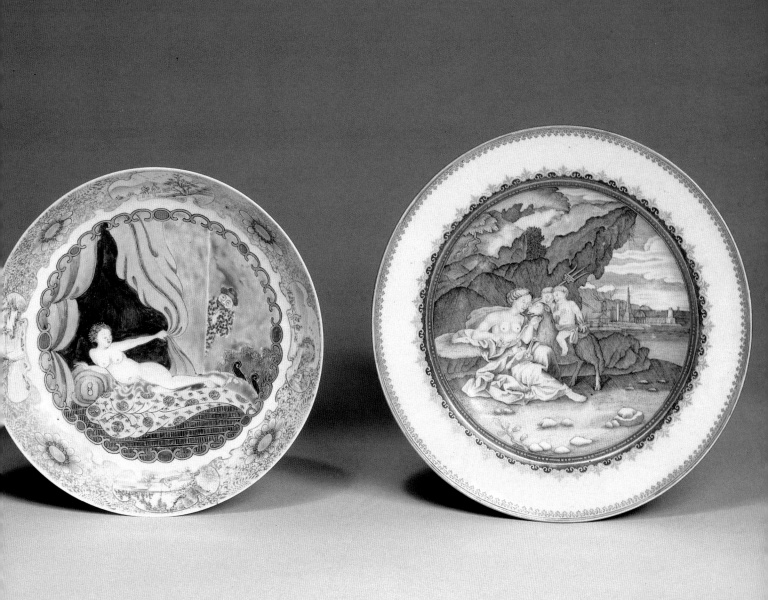

Even though by the first quarter of the eighteenth century porcelain was being produced in Europe, Chinese porcelain continued to maintain its popularity well into the century, so much so that the Chinese were actually copying European products of the period, particularly those of Meissen. A dish (54) painted with elaborate scrollwork and a quatrefoil panel containing *chinoiserie* figures is typical of designs produced by J. G. Höroldt at the Meissen factory in the 1720s and 1730s. The figure-group known as the 'Dutch Dancers' (53) deriving from a Meissen model by J.F. Eberlein, was probably copied from a Chelsea group of about 1755. Both Chelsea and Bow produced these models but unlike their Meissen proto-types the male figure is usually masked, as indeed is this Chinese example.

Political and social satire were not ignored as a subject for porcelain decoration. They derived from the graphic journalism of the propaganda print, broadsheet, and cartoon, which reached the height of popularity during the eighteenth century. The superbly painted punch bowl (55) is copied from a print by William Hogarth. Called *The Gate of Calais*, '*O the Roast Beef of Old England*', the original engraving was published in 1749 as a piece of anti-French vilification. Based on Hogarth's own experiences while in Calais (he depicts himself with a sketch pad to the left of the soldier with the musket), the rather ugly and unflattering figures pictured here represented for Hogarth the striking difference between all aspects of life and religion in France and England. Anti-Jacobite sentiment, which was rife following the 1745 Rebellion, is marked by the sad-looking Highlander seen in the lower right-hand corner. Hogarth's original engraving showed the arms of England and France over the gate, but on the punch bowl these have been replaced by the arms of the Rumbold family for whom the bowl was probably commissioned.

Some time during the reign of the Kangxi Emperor (1662–1722), the technique of painted enamels on copper was introduced to China, probably by Jesuit missionaries. The basic technique involved the application of an enamel ground to a copper base which was then fired. Further enamel colours were added as decoration, and the piece was then fired for the second time. Pieces were made for the home market as well as for export, and it seems probable that enamelling on copper was established in Canton some time at the end of the seventeenth century. The tea caddy (56) dates from about 1750, and was a necessary accessory to the by then well-established European pursuit of tea drinking. The caddy is decorated with conventional Chinese peony sprays and floral scrolls, unlike the vase (57), which is closely imitative of porcelain originals made at the Chelsea-Derby factory between 1770 and 1784. Produced by the Chinese in porcelain as well as enamel on metal, this form reflects the taste in late eighteenth-century Europe for neo-classical designs.

53 (*left*)
FIGURE GROUP
Porcelain with decoration in overglaze enamels
Known as the *Dutch Dancers*, the original model was made at the Meissen factory by J. F. Eberlein about 1735, but this group probably copied from a Chelsea model of about 1755
About 1755–1760
Height 14 cm
C.14-1951
Basil Ionides Bequest

54 (*right*)
DISH
Porcelain decorated in Canton with overglaze enamels and gilding
A scene derived from an original design by J. G. Höroldt of the Meissen factory
About 1735–1740
Diameter 24.8 cm
C.98-1956
Tulk Bequest

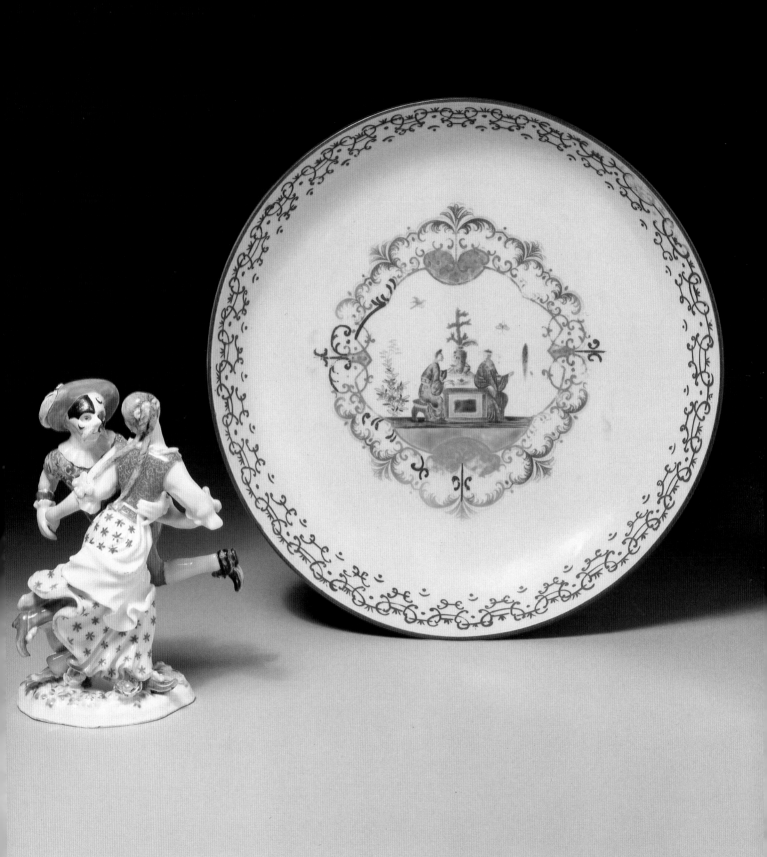

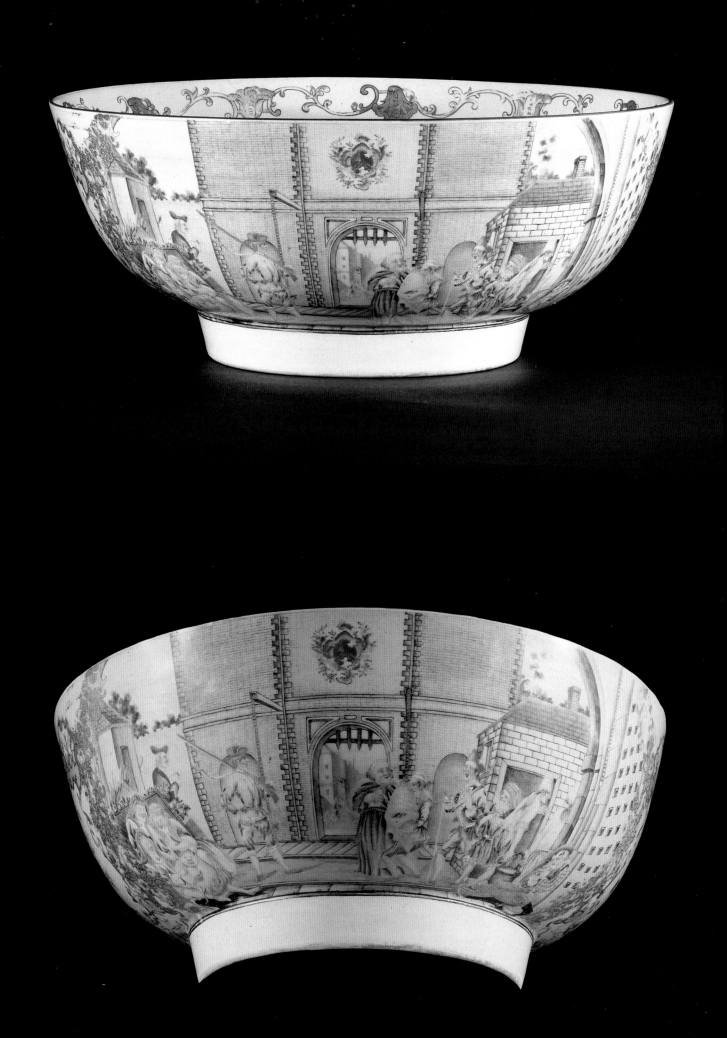

55 *(left)*
PUNCH BOWL
Porcelain decorated in Canton
with overglaze enamels
*The Gate of Calais, 'O the Roast Beef of
Old England'*, by William Hogarth,
published in 1749
About 1750–1755
Diameter 40.5 cm
C.23-1951
Basil Ionides Bequest

56 *(centre)*
TEA CADDY
Enamel decoration on copper
About 1750
Height 12.9 cm
FE.49-1970
Given by Brigadier Leslie H. Aste

57 *(right)*
VASE
Enamel decoration on copper
Copied from a porcelain original
made at the Chelsea-Derby factory
by William Duesbury 1770–1784,
to designs by Boreman and Asker
About 1780
Height 22 cm
FE.45-1983

The tureen in the shape of a boar's head (58) is just one animal shape of many that were produced for export. Such pieces were striking table decorations and were made both at Chelsea and at Strasbourg. Examples from these factories may have been the source for the Chinese model. The Dutch East India Company records reveal that twenty-five boar's head tureens were ordered by the Company in 1763, along with twenty-five goose-shaped tureens. In 1764 nineteen more boar's head tureens were ordered, but this time there was some doubt as to the commercial viability of handling such items and no other request was ever made, although no doubt they continued to be shipped as private cargo.

Not all porcelain for export derived its shape or decoration from Europe. The magnificent model of a pagoda (59), standing over nine feet high and made up of seventeen tiers, forms part of a western tradition of collecting exotica, and many such items appeared in materials other than porcelain. In fact models in porcelain of this size and quality are extremely rare, although a number of examples do survive. There are some eight pagodas in the Royal Collection, six of which are similar to the one illustrated. These were purchased by the Prince of Wales (later George IV) for the Pavilion at Brighton. From details in the Royal Archive it is known that they were bought in the years 1806 and 1816, and were expensive items. As it seems probable that they were all produced at the same workshop it can be assumed that the Museum's pagoda is of a similar date.

58
BOAR'S HEAD TUREEN
Porcelain decorated in Canton
with overglaze enamels
Copied from an original possibly
from either Strasbourg or Chelsea
About 1760–1770
Height 29 cm Length 37 cm
C.16-1951
Basil Ionides Bequest

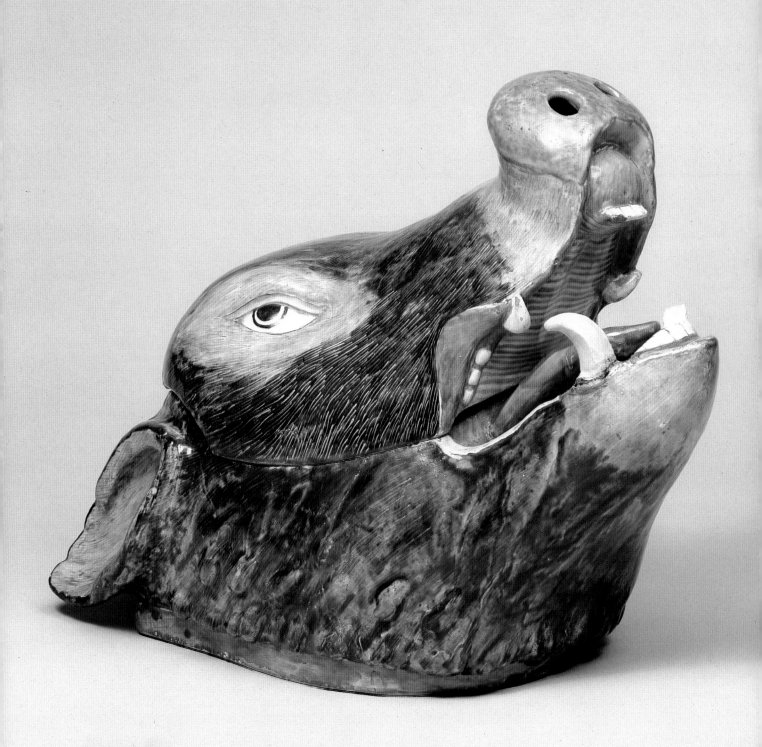

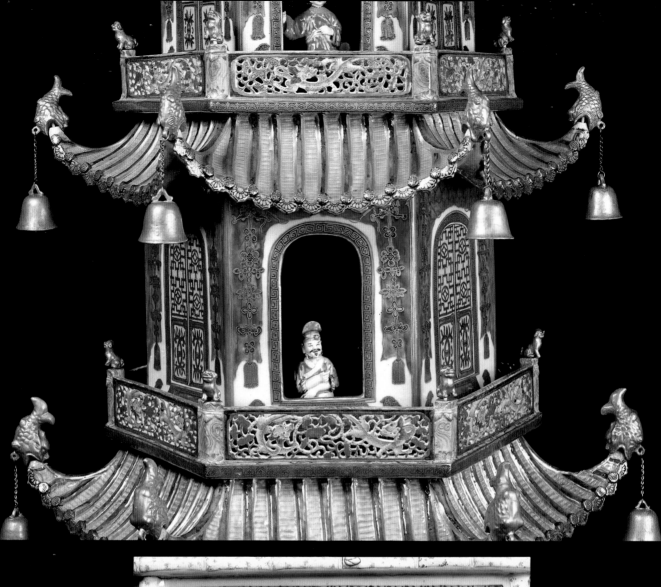

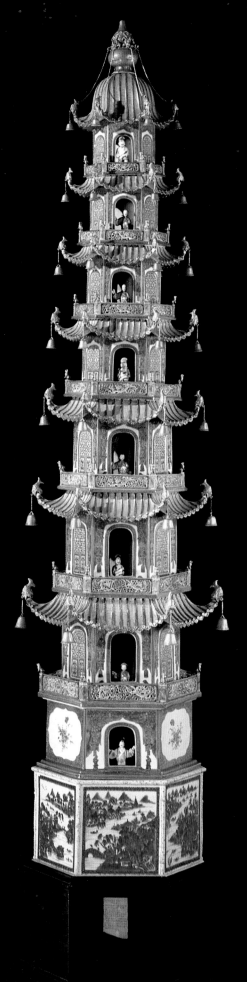

59
PAGODA
Porcelain with decoration in
underglaze blue and overglaze
enamels
About 1800–1815
Height 276 cm
C.80-1954

From about 1770, there was a noticeable decline in the popularity of Chinese porcelain. With the rise of entrepreneurs like Wedgwood in England, who marketed their wares aggressively, a change in taste that looked towards Europe rather than China for new inspiration, and a taxation system that worked against imported ceramics, even a shift towards neo-classicism on the part of the Chinese producer could not stem the changing tide. Fine though the mug (*60*) is, the only feature that distinguishes it from a bulk item is a scenic panel of Aberdeen Harbour and the name of the company for which it was made: 'The Commercial Banking Company of Aberdeen'. Indeed, the last time the English East India Company commissioned a service from the Chinese for its India Presidencies was about 1805, and the dessert basket (*61*) forms a part of this service. When a new service was required in 1818, it was to Worcester that the Company turned. NJP

60 (*left*)

MUG

Porcelain with decoration in underglaze blue, overglaze enamels and gilding added in Canton
A view of Aberdeen harbour surrounded by the motto *The Commercial Banking Company of Aberdeen*, probably copied from a banknote
About 1790
Height 13.5 cm
3713-1901

61 (*right*)

DESSERT BASKET AND TRAY

Porcelain decorated in Canton with overglaze enamels and gilding
Arms of the Honourable English East India Company
About 1800–1805
Basket Height 11.5 cm
Length 26.8 cm
Tray Length 26.5 cm
335 C&D-1898

Lacquer and Furniture

LACQUER is the sap of a tree, *Rhus verniciflua*, and has been tapped in China from prehistoric times. Originally used as a simple adhesive, or to provide a waterproof coating for wood, lacquer came to provide a considerable variety of decorative surfaces for furniture and for luxury utensils. Lacquered objects were certainly among the exotica admired by early traders and travellers to China. However by the end of the sixteenth century it was Japan which was firmly fixed in the western mind as the source of the best quality lacquering. The story of Chinese export lacquer can thus be summarised as a long attempt to fill the gap left by the exclusion from Japan of all western merchants, except for a small Dutch presence, after 1639.

The earliest piece of export lacquer in the collection is of a shape also seen in Japanese pieces, but in a technique which is not only distinctively Chinese but was relatively new when the casket was made. A Chinese lacquering handbook of 1625 calls the technique *kuan cai*, 'engraved polychrome'. It was known in seventeenth- and eighteenth-century England as 'Bantam work', after the port in Indonesia through which it was shipped. The name 'Coromandel' lacquer, often applied to it, appears to have been a French nineteenth-century invention.

In this technique the wooden carcase of the object is spread with a layer, a few millimetres thick, composed of a mixture of brick dust, pig's blood and unrefined lacquer. This is covered with coats of refined lacquer, usually of a black or brown colour, and the design is then cut into the lacquer until the greyish undercoat is revealed. The design is subsequently filled in either with coloured lacquers or with oil paints, the latter allowing a much richer and more varied palette. The Chinese lacquering handbook notes, 'The design is engraved in intaglio, like that of a printing block, and the colours are then inset – hence the name.'

The reference to printing blocks is interesting, as perhaps no other style of Chinese lacquering shows more clearly its dependence on graphic sources for its designs. The late sixteenth and early seventeenth centuries saw an increase in the numbers and sophistication of illustrated books being published in China. Colour woodblock printing was subsequently transmitted to Japan, where it was to reach even greater heights as an independent art form. The willingness of Chinese artisans to work from indigenous printed sources was to lay the groundwork for the eighteenth-century manufacture of goods with European motifs and decorative schemes. On this early casket (*62*), with its elaborate brass fittings in the manner of Spanish or Portuguese furniture, the top is decorated with a landscape, while the sides carry scenes of rocks and flowers, and the front shows a bronze vase with an elaborate flower arrangement. Despite the utterly western form of the object (one which is also known from Japanese *namban* lacquers), the decoration is totally Chinese, and very much in the style of a print workshop active in Nanjing from about 1630, known as the 'Ten Bamboo Studio'. The chest may well date

62
CASKET
Wood, covered in brown lacquer with incised coloured lacquer and oil paint decoration
Landscapes and vases of flowers
About 1620–1680
36.8 × 35 × 39.3 cm
FE.97-1974
Given by Sir Harry and Lady Garner

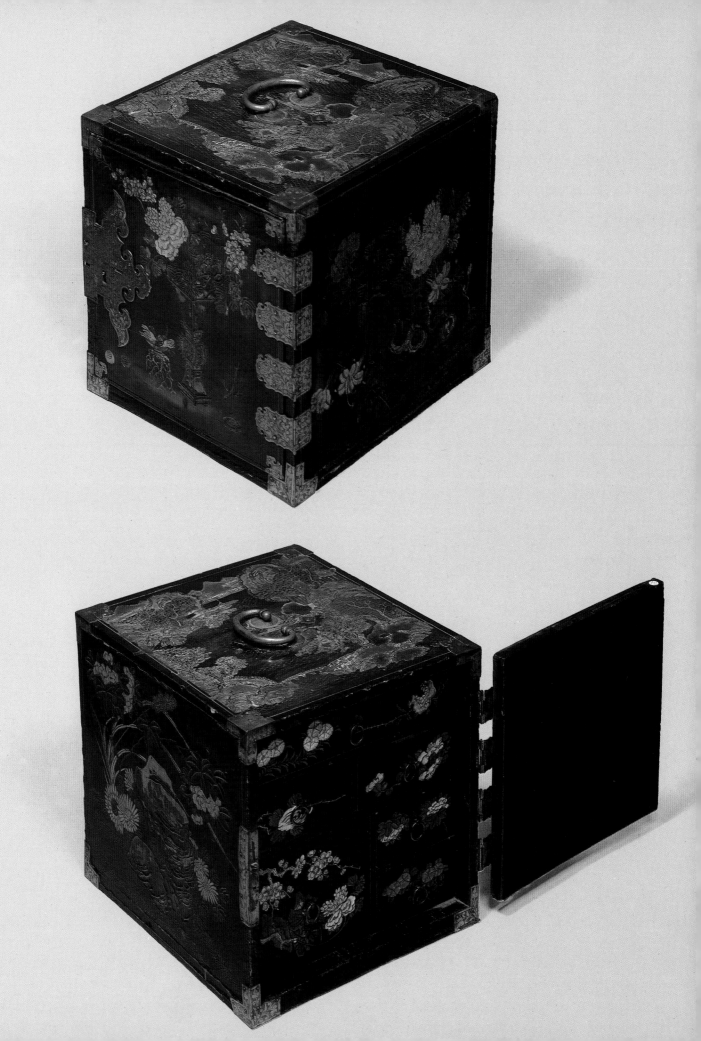

from the first half of the seventeenth century, when access was still possible to Chinese ports other than Canton.

A larger, more lavish and probably later piece of 'Bantam work' is in the form of a multi-drawer chest (*63*). Objects such as this survive in some numbers in the West. The stands are usually of European manufacture, the example here being English, of about 1810. The use of a gold ground and of borders of square and floral scrolling are both associated with the later part of the seventeenth century. Chinese carpenters' marks on the underside of the drawers all contain the number '4', suggesting the possibility that a batch of these cabinets was being assembled in the same workshop, with a certain division of labour.

Judging by the dates on a number of screens destined for presentation as gifts within China, the *kuan cai* technique enjoyed its heyday from about 1650 to about 1700, and declined thereafter. This may well be connected with changes in the taste of the westerners who had formerly been enthusiastic purchasers. In 1688 the influential *Treatise of Japanning and Varnishing* by John Stalker and William Parker noted that Bantam work was falling out of fashion in favour of painted lacquer, and it is certainly the latter technique which dominated the production of lacquer for export until the nineteenth century. Another factor may have been the greater suitability of painted lacquer for techniques of bulk production within the short trading season at Canton. Its final advantage was that gold lacquer on a black ground was associated in both the western and Chinese mind with the desirable but inaccessible products of Japan. Japanese lacquer had been a fashionable import to China since at least the fifteenth century, and was highly esteemed by Chinese connoisseurs. The technique of *maki-e*, 'sprinkled pictures', where a design is created by dusting fine gold powder over an outline previously painted in wet lacquer, had been developed in Japan, but was transferred to China at some stage. By at least 1700 it was a speciality of Canton, which supplied not only the seasonal export trade but the much larger domestic market for *yang qi* 'foreign lacquer'. Specialists in this technique were summoned from Canton to the court workshops in Peking in the 1720s, where they not only executed pieces in a close pastiche of Japanese styles but pieces which combined the purely Chinese technique of carved lacquer with the gold on black lacquer usually destined for export. The export and domestic craft markets rarely worked in isolation, but this is a particularly striking example of their close inter-penetration.

Several contemporary descriptions of nineteenth-century export lacquering workshops survive, and there is no reason to suppose that they are not also valid for an earlier period. Following the priming of the wooden surface, and the filling of any cracks with paper soaked in a mixture of pig's blood and powdered shell, anything from three to fifteen coats of lacquer were brushed on and polished down. The design was applied using a pounced pattern, with powdered chalk or white lead being rubbed through the pinholes in a sheet of paper to lay down the outline. These lines of powder were then painted over with a mixture of lacquer and vermilion, onto which the gold dust was powdered while still wet. Camphor was occasionally added as a way of setting the gilding. Alternatively, the outline of the design was lightly incised into the lacquer with a metal stylus before the lacquer and vermilion were applied.

No western ship sailed to China just to buy furniture. Although the Honourable East India Company had occasionally traded in lacquered wares on its own

63
CABINET
Wood, covered in gold lacquer with incised coloured lacquer and oil paint decoration
Landscapes and flowers
About 1700
The stand English, about 1800
79 × 90 × 53.5 cm
FE.39-1981

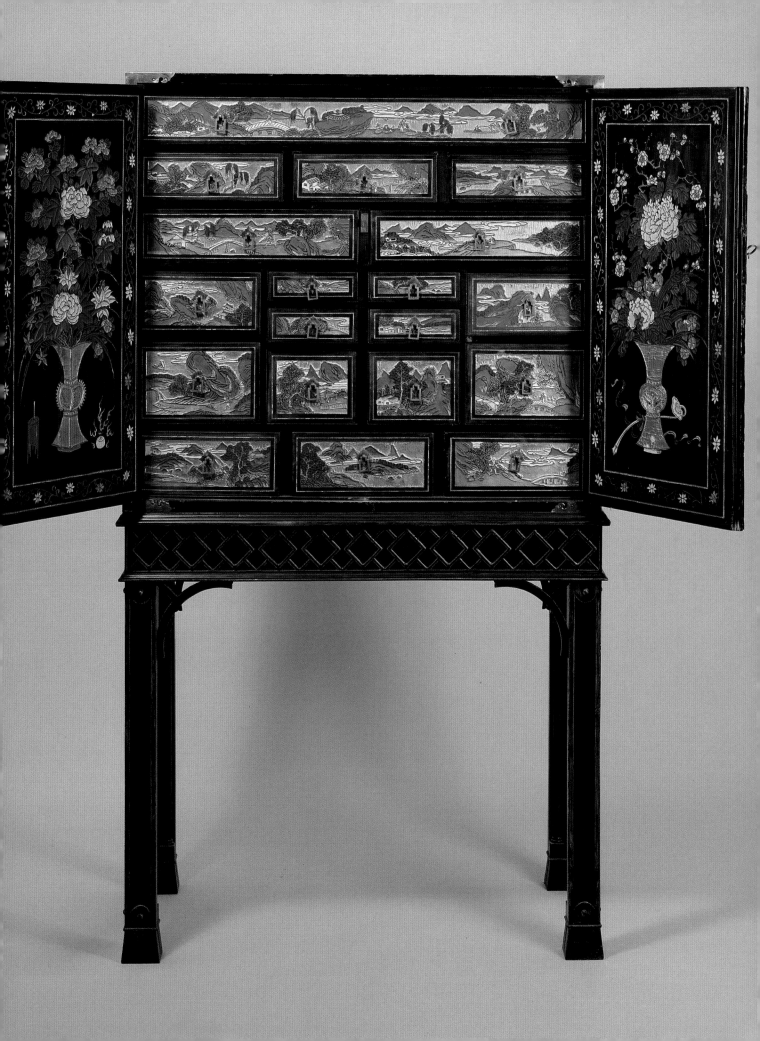

account in the later seventeenth century, their profitability had never been great. From the eighteenth century the shipping of furniture was wholly in the hands of individual captains or merchants of the company, forming part of their private trade. Not only large pieces of furniture, but small lacquered items were ordered from workshops in Canton itself. These small items were often distinguished by their close adherence to supposed Japanese models. On the box (*65*), the colour scheme and shape are of Japanese inspiration, while the makers have also attempted to imitate the strongly vertical composition of much Japanese lacquer-work. Western shapes soon came to dominate export lacquer production. A barber's bowl (*64*) of lacquered leather shows several of the design features which were to become standard. The combination of areas of geometric patterning with cartouches containing very stylised scrolling foliage is seen on much of the material, including large screens, chests and sets of chairs (*66, 67, 68*), from the period about 1730 to 1770. There is no evidence that carcases of furniture were sent to Canton to be lacquered there, and it therefore seems likely that the makers of export furniture worked principally from western drawings. The Swede Olof Toreen, in Canton in 1751, noted that, 'The joiners copy everything that is shown them.' His contemporary Peter Osbeck added that, 'The Jappaners have already made bureaux, tea-boards, boxes &c. beside the work that is bespoken.' However the majority of pieces were made to special order, as the workshops preferred to wait for the arrival of the western ships before beginning work. Their skill in interpreting an unfamiliar design idiom was impressive, though the quality of finishing was often not high. French missionary observers, familiar with the work done in the Palace workshop in Peking, attributed this to the haste necessary to complete orders within a short trading season. The all-important priming of the wood surface was skimped, and insufficient drying time was allowed for each coat of lacquer. There are, however, considerable differences observable in the quality of finish on surviving pieces. The lacquer on a large six-panel folding screen (*66*) is much thicker and retains a better lustre than that on a dining chair (*68*), once part of a set of eight originally at Warwick Castle.

64 (*left*)
BARBER'S BOWL
Pigskin, covered in black lacquer with gold lacquer decoration
An unidentified French or Dutch coat of arms
About 1740
Width 34 cm
FE.99-1982

65 (*right*)
BOX AND STAND
Wood, covered in black lacquer with gold lacquer decoration
Landscape
About 1750
15.7 × 8.4 × 12.7 cm
W.316-1921
Sage Gift

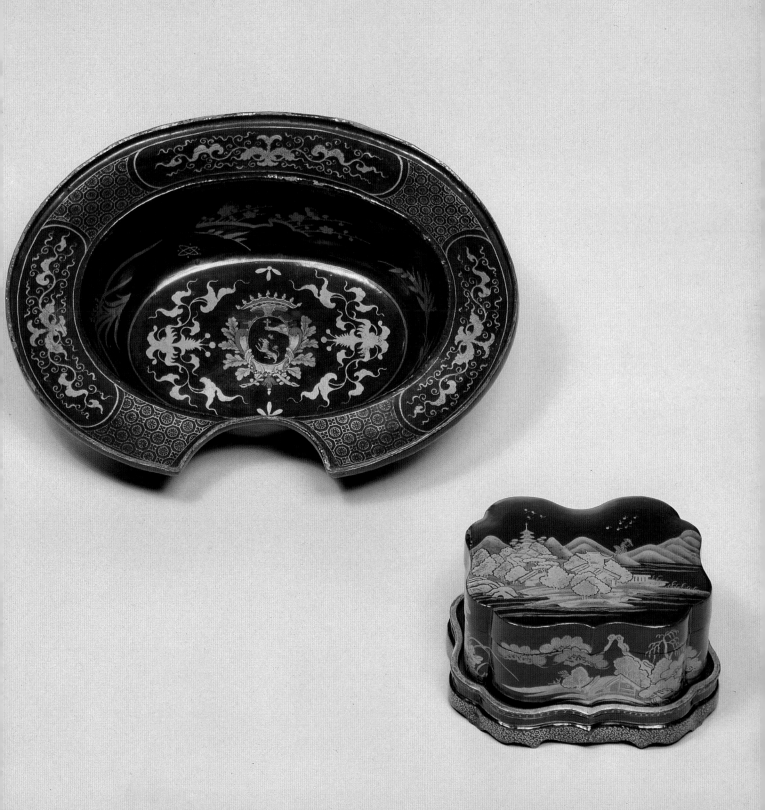

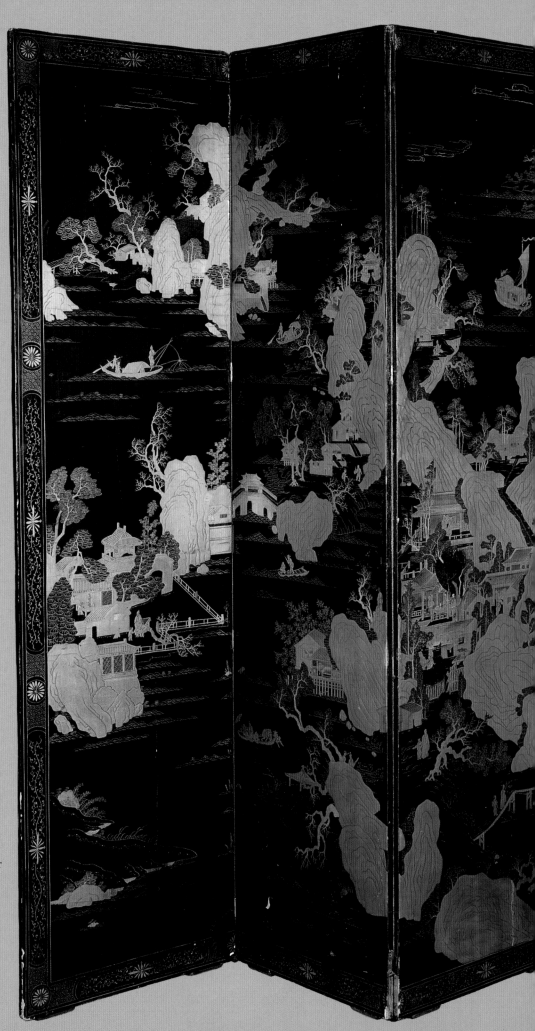

66
FOLDING SCREEN
Wood, covered in black lacquer
with gold lacquer decoration
Landscape
About 1730–1770
218 × 366 cm
W.37-1912
Given by S. Mavrojani

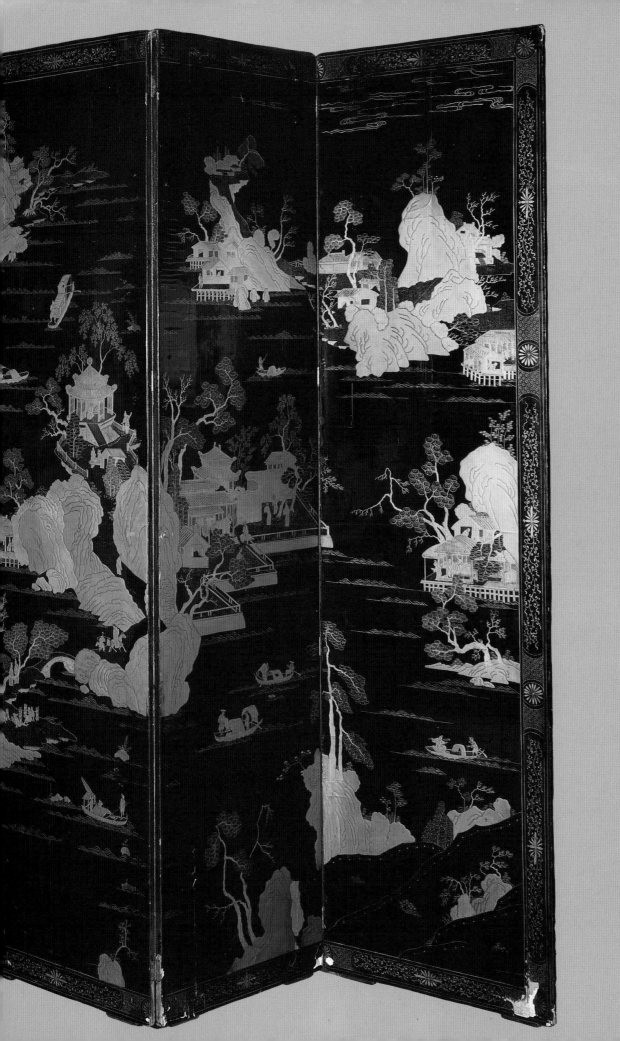

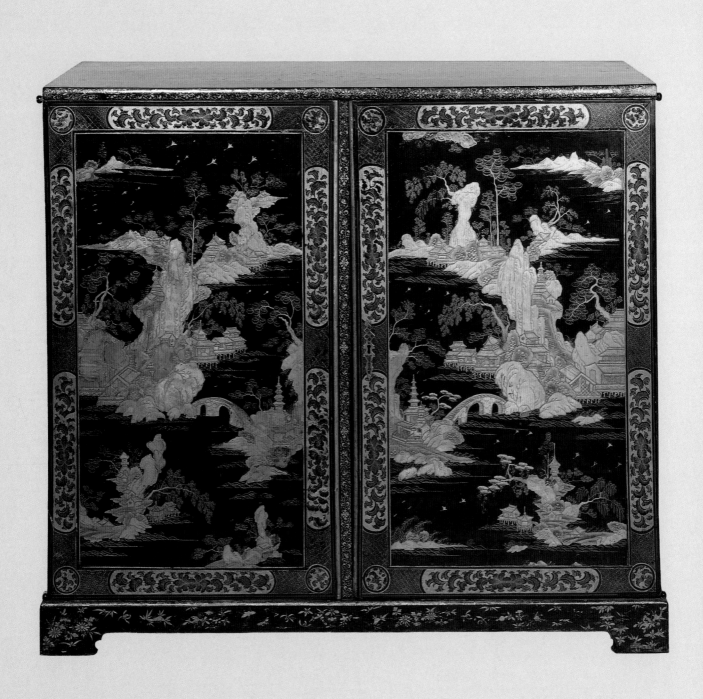

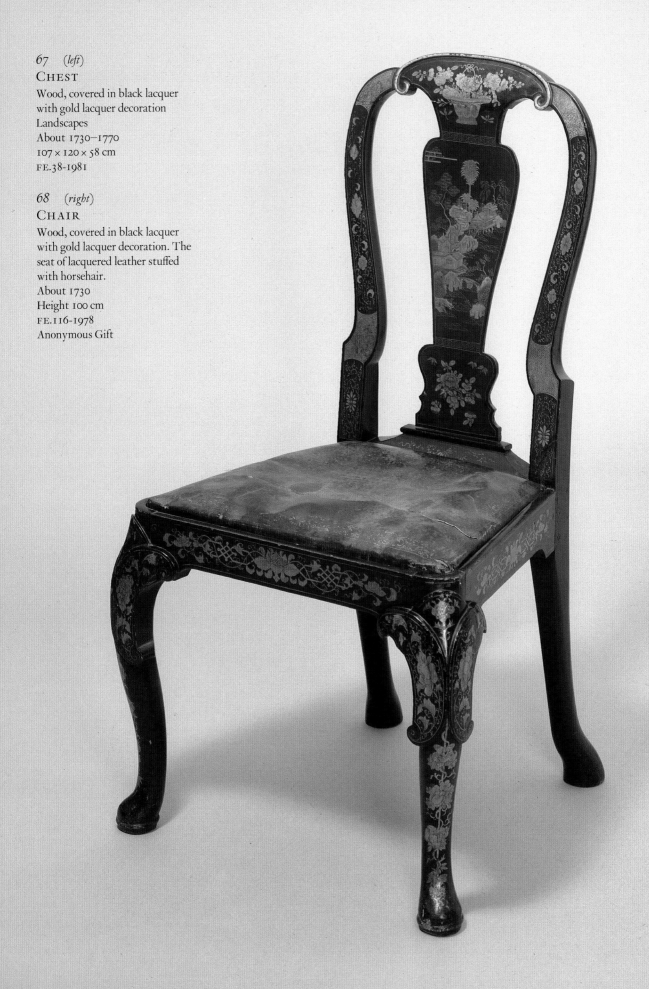

67 *(left)*
CHEST
Wood, covered in black lacquer
with gold lacquer decoration
Landscapes
About 1730–1770
107 × 120 × 58 cm
FE.38-1981

68 *(right)*
CHAIR
Wood, covered in black lacquer
with gold lacquer decoration. The
seat of lacquered leather stuffed
with horsehair.
About 1730
Height 100 cm
FE.116-1978
Anonymous Gift

Little is known about the organisation of the workshops in which export furniture was made. It is unlikely that any workshop devoted itself just to western customers, and the major part of the year was almost certainly spent on work for the much larger Chinese market. The rush to fulfil large orders in a short period may however have stimulated division of labour within the workshops, and helped to bring about the situation where, by the nineteenth and twentieth centuries, Canton was one of China's main furniture-making centres. Part of the reason for Canton's pre-eminence was its access to supplies of close-grained hardwood timber from South-east Asia. These timbers, members of the *Pterocarpus* and *Dalbergia* families, had become particularly fashionable in China for furniture-making from the middle of the sixteenth century. It seems likely that European participation in inter-Asian trade actually increased supplies of these woods, known at the time generically as 'rosewood' in English. A large secretaire bookcase (*69*) made at Canton in about 1770 would be almost unidentifiable as a Chinese piece were it not for the ink inscription in characters left on a concealed surface by its maker, 'Ship's captain no 4 – Bookcase'. The fact that the Chinese maker knew he was working on a bookcase is interesting. There is nothing about the shape of the piece to suggest the storage of books in a Chinese cultural context. The fact of the object's function must have been transmitted along with the order for it. The glass in the upper portion was certainly imported from Europe, and the metal fittings may possibly have been imported too.

Another object combining English glass with Chinese woodwork is a small case of decanters (*70*), carved externally to resemble the carvings from root wood which were fashionable in eighteenth-century China for small stands and table furniture. The gnarled appearance would have fitted equally well into a contemporary English aesthetic of the 'rustic'.

Little hardwood export furniture for the English market seems to have been made after about 1800, though lacquering continued to be popular into the mid nineteenth century. The Japanese-inspired landscape designs gave way in the very late eighteenth century to dense geometric patterns. One distinctive decorative scheme from this period has curling grape vines against a ground closely decorated with a diamond pattern. Large pieces of furniture in this style are known, but also typical is a tea caddy (*71*) decorated with the owner's initials. It contains two internal caddies in pewter and still retains a lock, a reminder of tea's early status as an expensive luxury.

A workbox for sewing tools (*72*) dates from some forty years later, from the decades when the China trade was taken over by the private trading houses. Western design has here given way to 'exotic' Chinese decoration of figures, pagodas and junks. As with much nineteenth-century porcelain, the scene has no meaning in Chinese terms, and serves for the western customer only to underline the foreign nature of the product at a time when the technical or price advantages of imports from China were being decisively eroded by mass production and new techniques. It was, as noted by S. Wells Williams in 1863, the development of papier mâché as a cheap material which would take a high-gloss varnish finish, which killed off the trade in Chinese lacquered, 'fans, waiters, chess-boards, work-tables, segar-[cigar] boxes, tea-trays, teapoys etc.' A poorly finished plate (*73*), one of the Museum's earliest acquisitions of Chinese lacquer, is a typical product of those declining years, as is a box (*74*) with the by then ubiquitous dragon decoration. CC

69
SECRETAIRE BOOKCASE
Huali wood (*Pterocarpus sp.*)
About 1770
111 × 198 × 55.5 cm
FE.104-1982

70
CASE OF DECANTERS
Huali wood (*Pterocarpus sp.*)
About 1780
30.3 × 16.5 × 20 cm
FE.48-1976

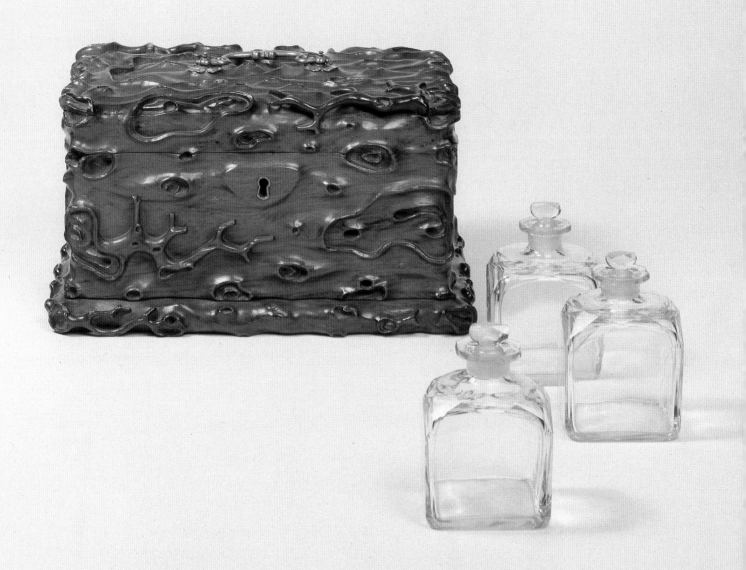

71
TEA CADDY
Wood, covered in black lacquer
with gold lacquer decoration
Containing two pewter caddies
The monogram WJCCB on the lid
About 1790–1820
21.4 × 13.7 × 12.5 cm
FE.170-1975
Mrs Constance Elizabeth Horton
Bequest

72

SEWING TABLE
Wood, covered in black lacquer
with gold lacquer decoration. Silk
bag and ivory fittings
The lid with scenes of figures in a
landscape
About 1830–1850
Height 73 cm
FE.27-1981
Given by Miss E.P. Cross

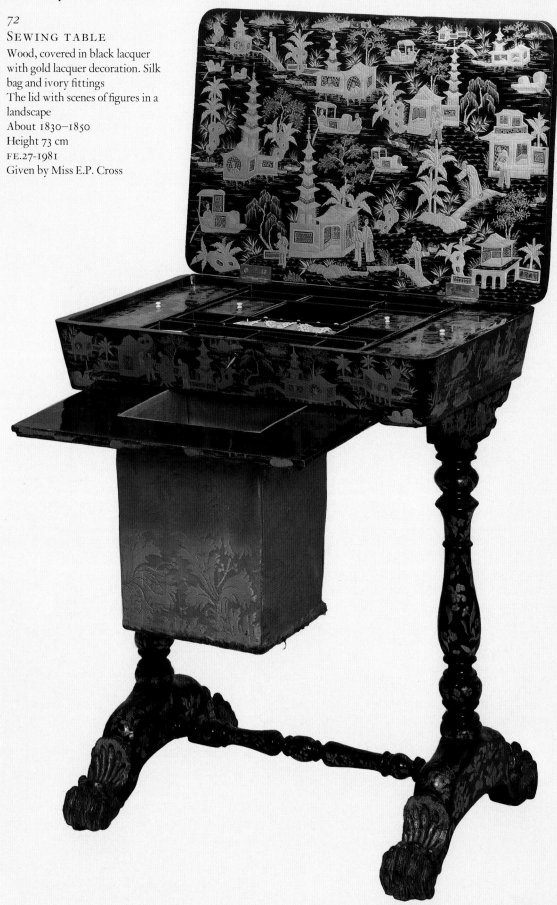

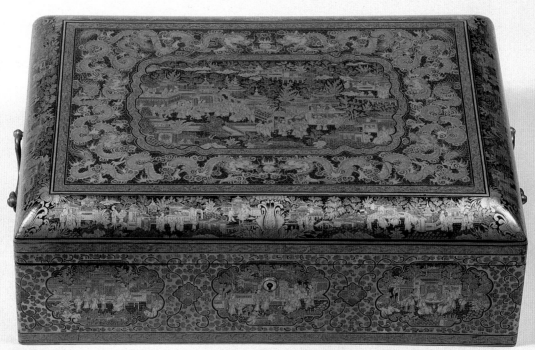

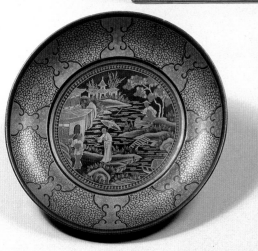

73 *(left)*
PLATE
Wood, covered in black lacquer
with gold lacquer decoration.
Landscape
About 1850
Diameter 15 cm
36-1852

74 *(right)*
BOX
Wood, covered in black lacquer
with gold lacquer decoration
About 1860
44.5 × 13.5 × 31 cm
177-1898
Johnson Gift

Carving

ELEPHANT ivory was available in China from very early times, and was used as a decorative and inlay material as well as for small carvings in its its own rights. However the supply of the material, from Africa, India and South-east Asia, was greatly facilitated from the sixteenth century by the participation of western merchants in maritime trade between these regions. As early as 1600, the Portuguese were regularly carrying ivory to the port of Canton from their settlement at Goa on the west coast of India. The Dutch, and later the English East India Companies, also took part in this trade, which helped to establish Canton as the single most important centre of ivory working in China, supplying both the huge domestic trade and the much smaller export market. As with lacquer, Canton workshops enjoyed a reputation all over the empire, and carvers from there were summoned to court on several occasions.

The earliest ivories carved to order for western customers were Christian religious images and small plaques decorated with Christian subjects. However, by the eighteenth century a much wider variety of European forms was being produced, making ivory carving one of the more important of the sideline crafts supplied to western merchants as part of their private trade or as souvenirs.

Fans formed one of the most significant types of export object in ivory, and indeed ivory fans were made solely for export. On the earliest examples (75), the ivory merely forms a surface for painting and gilding. Here the decoration of flowers, mythical beasts and European figures is closely related to that seen on porcelain enamelled in the so-called 'Chinese Imari' style (18, 20). Also reminiscent of the decoration on contemporary porcelain is a fan (76) where the outer guards are of ivory, but the leaves themselves are made from very thin sheets of the mineral mica. From a much later period comes an intricate but typical example (77) of a fan where it is the ivory itself, carved in openwork with a mixture of Chinese geometric patterns and a European neo-classical shield medallion, which forms the object's decorative interest.

Other exotic imported materials were utilized in Canton carving workshops. One of these was mother of pearl (a term used for the lustrous layers found on the interior of the shell of some molluscs), which is used here (78) as the covering for a wooden box, lined with paper decorated with metallic foil. This in turn contains three boxes full of counters, used in Europe for keeping the score and as stakes in various gambling games. The tokens are incised with the arms of the Best family, who were involved with trade to Asia throughout the eighteenth century, and who ordered armorial porcelain for themselves on at least two occasions, in 1730 and again in 1775. This box was possibly ordered with the second set.

A much larger compartment ivory box (80), from the end of the eighteenth century, is covered on all its upper surfaces with dense decoration of entertainers of various kinds: jugglers, acrobats, lion dancers and so on. This style points

75
FOLDING FAN
Carved ivory with painted and gilded decoration
Westerners, mythical beasts and flowers
About 1700–1730
Length 25.5 cm
2256-1876
Wyatt Gift

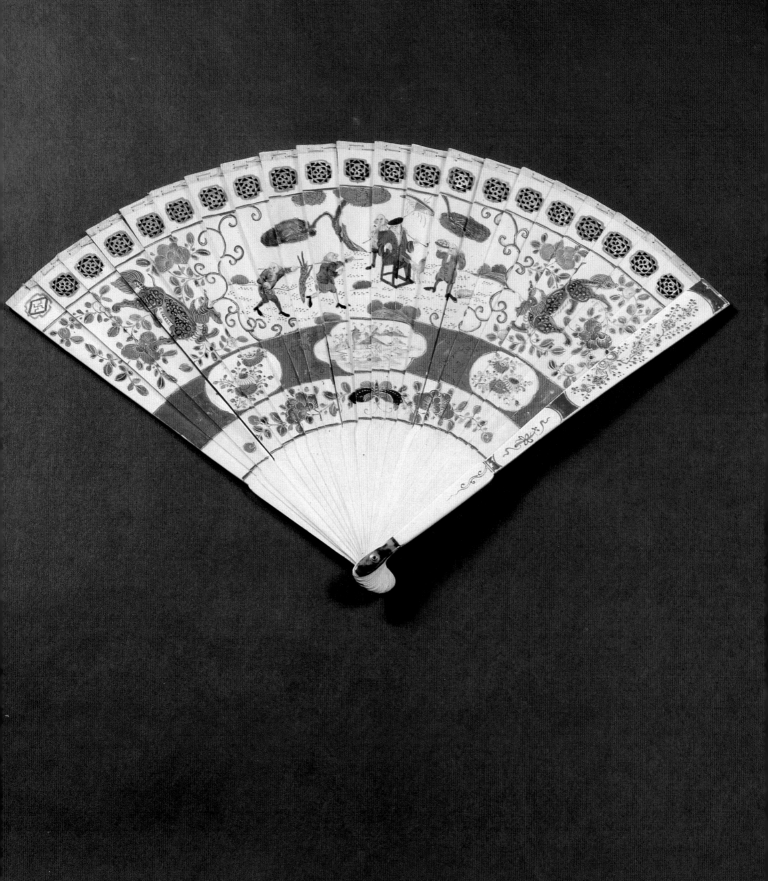

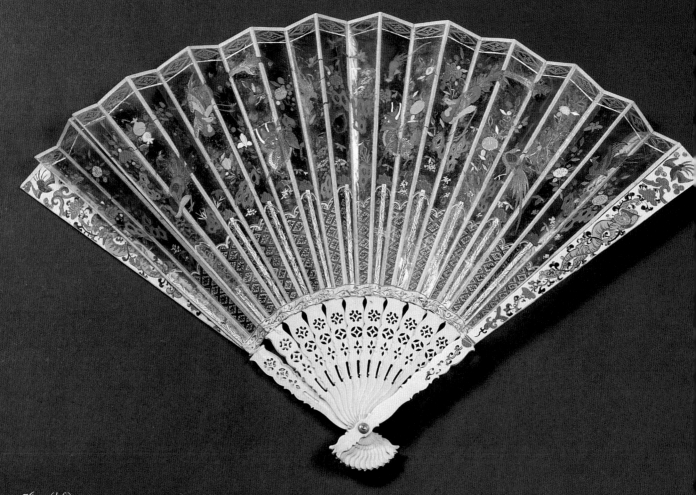

76 *(left)*
FOLDING FAN
Painted ivory guards and sticks,
leaves of mica with painted
decoration
Mythical beasts, birds and flowers
About 1730
Length 26.7 cm
FE.29-1980

77 *(right)*
FOLDING FAN
Carved ivory
With the monogram MD
About 1790–1810
Length 25.3 cm
2248-1876
Wyatt Gift

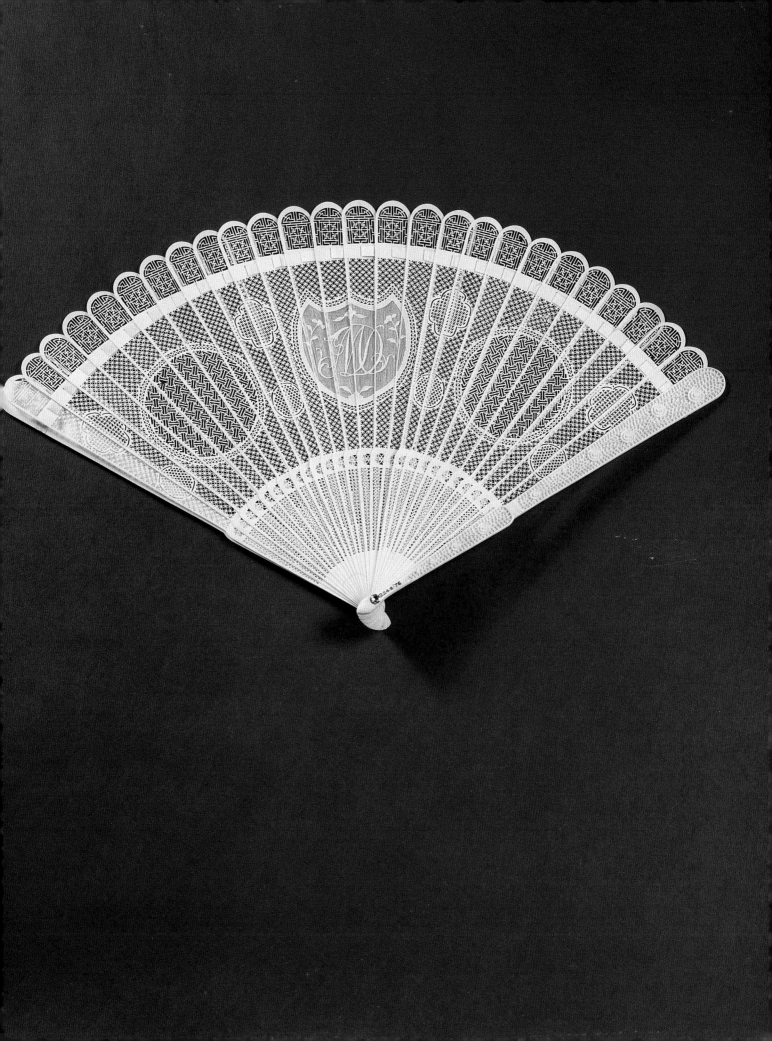

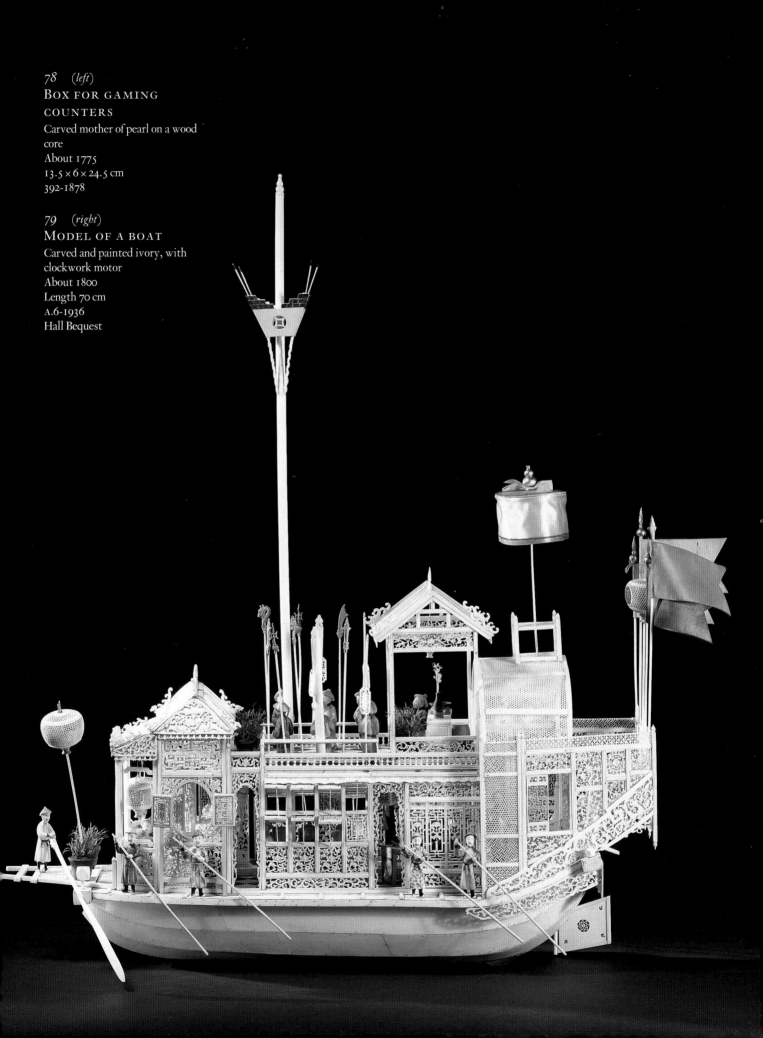

78 *(left)*
BOX FOR GAMING
COUNTERS
Carved mother of pearl on a wood
core
About 1775
13.5 × 6 × 24.5 cm
392-1878

79 *(right)*
MODEL OF A BOAT
Carved and painted ivory, with
clockwork motor
About 1800
Length 70 cm
A.6-1936
Hall Bequest

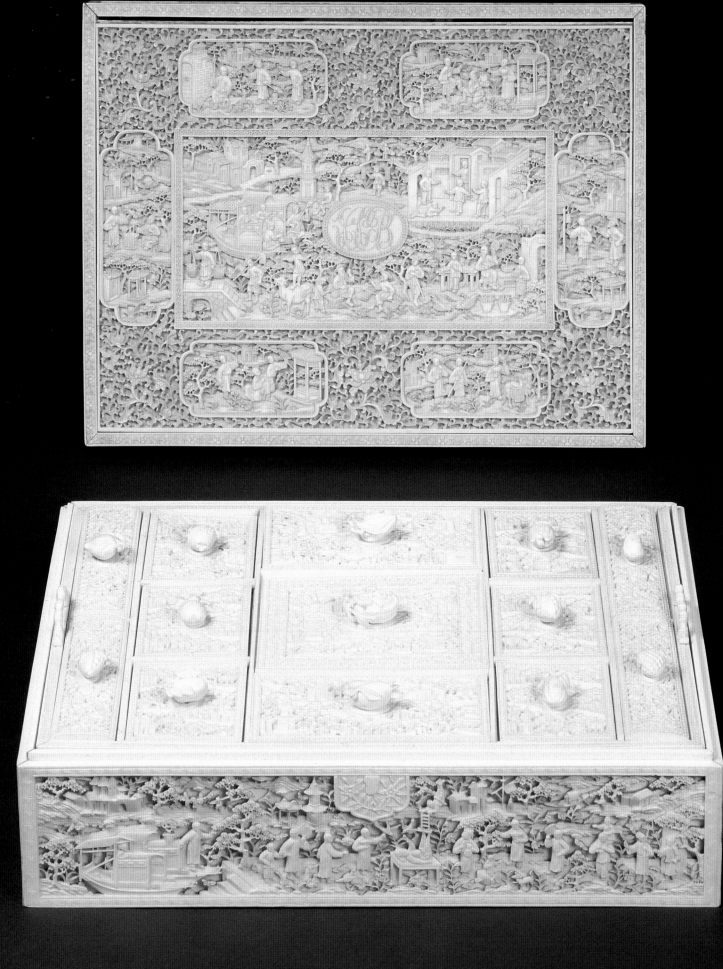

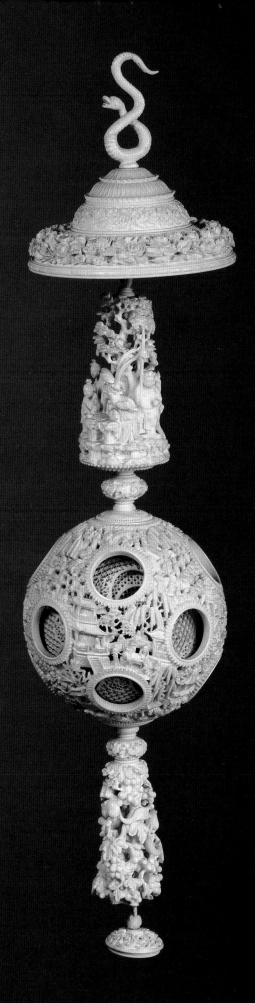

80 (left)
WORKBOX
Carved ivory
Musicians, jugglers and lion
dancers
With the monogram CSB
About 1790–1810
36 × 11 × 26.5 cm
1769-1892
Ingle Bequest

81 (right)
PENDANT OF
CONCENTRIC BALLS
Carved ivory
About 1820–1840
Length 45.7 cm
380-1872

forward to the typical lacquer decoration of the nineteenth century (72), where again the dominant feature is a crowd of figures. The carving here is in particularly high relief, and is even undercut in some places. The background has been cut down to such a thinness that it is translucent.

Even more intricate is a large ivory model of a boat (79), bearing the insignia of a *jiang jun* or General, which is mounted on wheels powered by a clockwork motor. Such mechanized models, together with similarly powered pavilions with moving figures and animals, were a popular souvenir of Canton, fulfilling the same set of western expectations about China which is seen in the porcelain pagoda (59). By 1803, when this piece was brought to England by Richard Hall (1764-1834), formerly chief supercargo at Canton, the Chinese had developed a thriving clock, watch and clockwork industry, independent of the European prototypes which had reintroduced the technology to China about two hundred years previously.

Sets of concentric ivory balls (81) were and remain one of the most fascinating products of the trade in decorative items. The earliest Chinese citation for them, under the name of 'devilwork spheres', appears in a text dated 1388, though no example of this age is known to survive, and they seem not to have been a significant form of decoration in Chinese interiors. The technique was practised in Europe from about 1500, and reached a high point in the seventeenth century, when turning was a fashionable aristocratic pursuit, although in the nineteenth century it was commonplace to claim these technical *tours de force* as uniquely Chinese. There is no great mystery about how they were made, and one of several clear descriptions can be found in S. Wells Williams' *The Chinese Commercial Guide* of 1863:

> A fine piece of ivory is chosen and worked to an exact sphere; several conical holes are cut into its body, all meeting in the centre by means of drills working to a gauge, so that each hole will be of the same depth. The centre being bored out an inch or so, the mass of ivory is fixed firm with wedges, and a line is drawn far inside of each conical hole at the same distance from the surface; the workman cuts into this line with knives working on a pivot, and passes around the sphere from one hole to another, cutting into the sides of each until the incisions meet and the central sphere is loosened. Its faces are then turned over to the holes, so that they can be smoothed or carved with proper tools, before proceeding to the next. Another line is then drawn outside of this sphere, and the same process of cutting repeated till another is loosened, and the new surfaces polished like the first. In this way all the concentric spheres are cut out; about three months labour is required for a large ball . . .

In this example, at least eighteen concentric layers of carving are present.

The carving workshops which generally worked in ivory also produced pieces in tortoiseshell, like a small box (82) fitted with a lock and probably meant as a jewellery box, carved in the crowded style of the early nineteenth century. CC

82
WORKBOX
Carved tortoiseshell
Landscape with figures
About 1820–1840
17 × 9.5 × 25.5 cm
639-1877

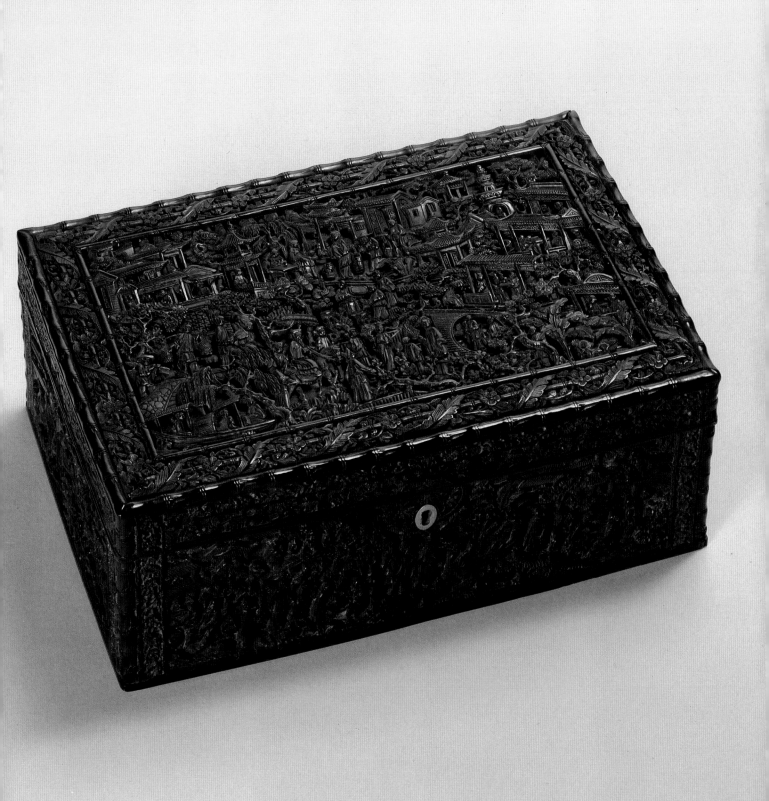

Metalwork

ILVER and, to a lesser extent, gold were the standard tablewares of the very
wealthy in Ming and Qing China, and the lavish table services of the
wealthy Canton merchants were frequently remarked upon by westerners
who dined with them. Silver bullion also circulated through the empire and was
used by weight in place of a minted currency. It was brought to China in very
large quantities by foreign merchants to purchase Chinese goods. There is no
evidence that items of precious metal were regularly re-exported from China
before about the end of the eighteenth century, though by the nineteenth century
the very low cost of labour in China made it feasible to have western tableware
and cutlery copied in Canton. Trade in silver items flourished particularly with
America, unhampered by the close watch on purity of metal which the Worshipful
Company of Goldsmiths rigorously enforced in Britain.

However the occasional piece of silver or silver gilt in eighteenth-century style
does exist, as this tea caddy (83) proves. It closely follows an English shape,
though retaining elements of the Chinese metalworking tradition, such as the lion
masks carrying the handles and the small lion knop to the lid. The body of the
caddy is lavishly decorated with ornate filigree. This technique seems to have
been a speciality of Canton, and very large quantities of it were made for the
thriving export trade with India and South-east Asia. For Europeans and Amer-
icans, it was made into jewellery and small personal items such as card cases.

Some time after 1800, Chinese silversmiths began to mark their work in
imitation of the hallmarks they saw on the objects they were being asked to copy.
Both Chinese characters and imitations of western, usually London, marks can be
found on the same object, though there does not always seem to have been a
consistent convention about using the same Chinese marks with one set of
western style ones. These pseudo-hallmarks can, however, be a way of identifying
individual workshops in Canton and later in Shanghai, where the practice spread
after the opening of that city to western trade in 1843. One of the most prolific of
the Canton workshops was that known to western customers as *Khecheong* (the
correct reading of the characters would be *Qichang*), which marked its products
with an imitation of the London hallmark and the letters KHC. The shop was
situated on Henan Island, just across the Pearl River from the old foreign factories,
and was active throughout the middle of the nineteenth century. A splendid
incense burner (84) on a stand of writhing dragons, with the body decorated in
repoussé (where the design is hammered through from the back), and with applied
shellfish and crustacea, is a typical product of its most flourishing years. The taste
for explicitly and even stridently 'Chinese' decoration, which became so marked
in the decades following the First Opium War, is very much to the fore here,
though the piece does have a distinguished pedigree in Chinese hands. It was a gift

83
TEA CADDY
Silver gilt
About 1760
Height 18 cm
M.114-1919
Oppenheimer Gift

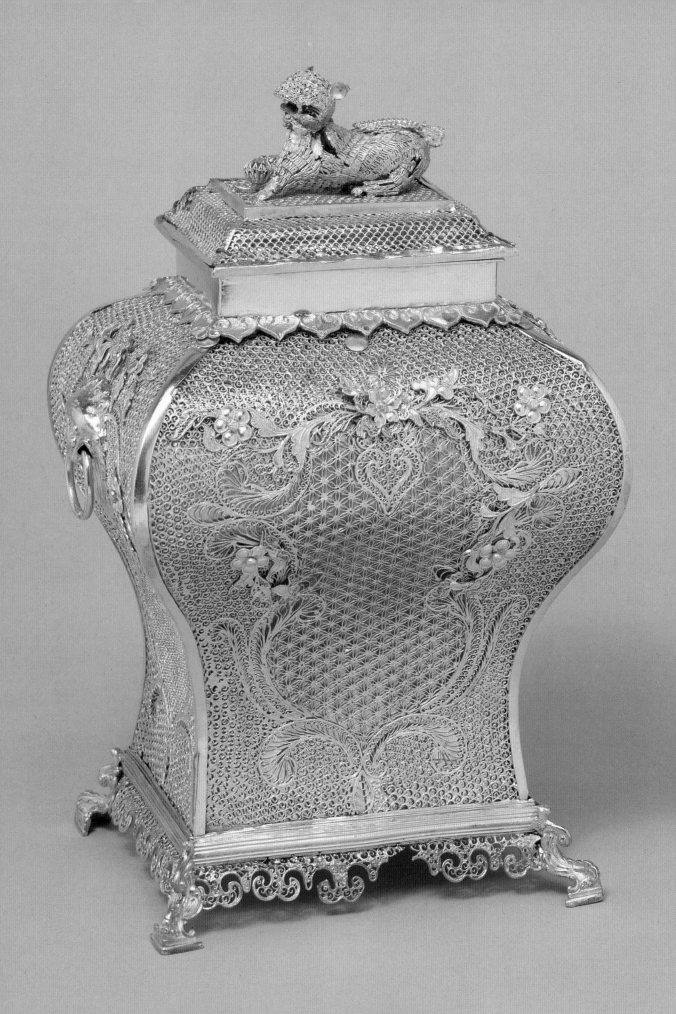

to the China Society from the Chinese Ambassador to Britain in 1914, when it was already about sixty years old.

A much more modest object from an unidentified Shanghai workshop marking its pieces with the Chinese characters *Baoxing* takes the form of a cigarette box (85), also decorated in repoussé with sea creatures against a ground of ring matting produced by the use of a circular punch. This was probably made as a tourist souvenir or for export, as Shanghai developed into the largest western community in East Asia and an obligatory stop on any world tour. The same is probably true of two goblets (86, 87) made by the workshop known as *Luen Wo* (sometimes represented by the Chinese characters *Liangru*), which had its shop on Nanking Road, the main shopping street of Shanghai's International Settlement, catering almost exclusively to western customers. The ubiquitous dragons are combined here with the flowing lines of the international *art nouveau* style, as China's craft producers attempted to retain their place in the world market, responding to their customers in a seemingly age-old manner, but in the changed conditions of a nation under both cultural and economic assault. CC

84
INCENSE BURNER
Silver
Dragons and sea creatures
Marks of the *Khecheong* workshop
About 1850
Height 40 cm
China Society Loan

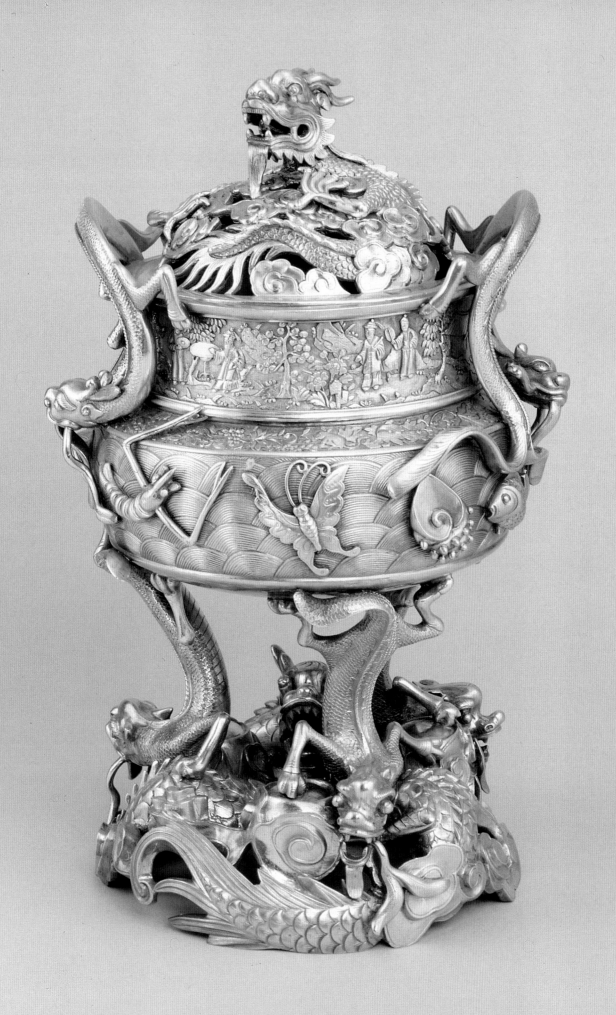

85 (*left*)
CIGARETTE BOX
Silver
Sea creatures
Marked *Baoxing*
About 1880
16.5 × 4 × 10 cm
470-1894

86 (*centre*)
GOBLET
Silver
Dragons
Marked *Liangru*
About 1900–1910
Height 17 cm
FE.11-1980

87 (*right*)
GOBLET
Silver
Dragons
Marked *Liangru*
About 1900–1910
Height 17 cm
FE.10-1980

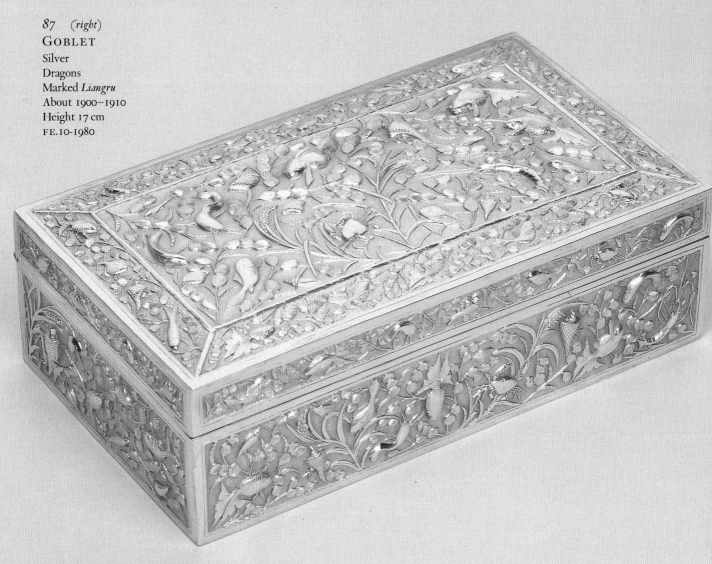

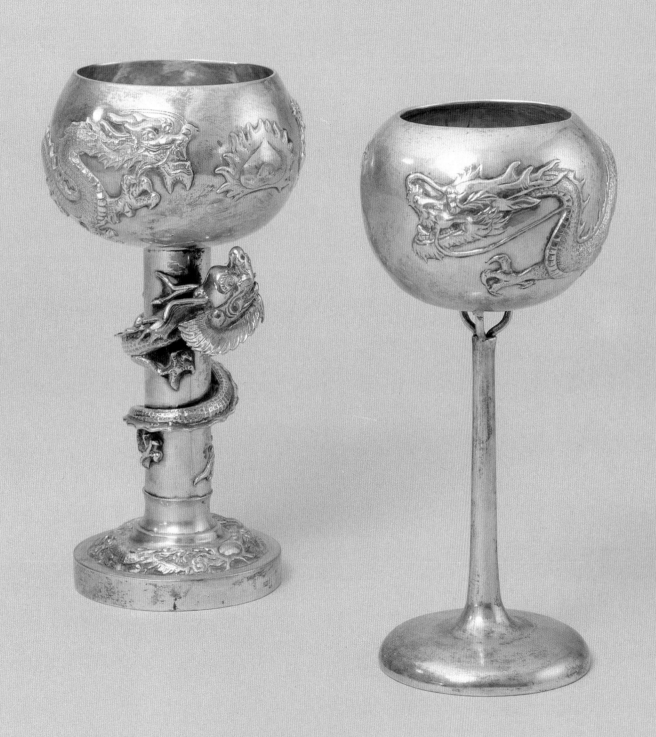

Wallpaper

THE painted paper panels imported from China for use as wall decorations from the late seventeenth until well into the nineteenth century have very few antecedents in the native tradition of interior decoration. Those early missionary visitors to China who, unlike their merchant contemporaries, managed to penetrate the homes of the élite were struck by the relative bareness and lack of decorative surfaces within the elegant Chinese interior, where lacquered furniture, paintings and *objets d'art* took the place of the wall murals or tapestries with which they were familiar in Europe. One of them did record that the Chinese covered their walls with paper, and this has often been taken to mean that painted wallpaper had roots in China itself, but what Father Du Halde in fact was referring to was the covering of walls with sheets of plain, undecorated paper to give a smooth white surface. When the first British Embassy was being installed in a commandeered palace in Peking in the early 1860s, the walls there were similarly papered with plain sheets of roughly a foot square, giving a glossy satin sheen to the walls.

It seems therefore that the manufacture of painted wallpaper results from a congruence of two separate Chinese factors: the papering of walls with plain sheets, and the decorative painting tradition discussed below (p.116), used to producing large panels either for the hanging scrolls used in reception rooms or for mounting on screens.

The first Chinese wallpapers to reach Europe seem to have done so in the 1690s, and they retained their popularity in England and elsewhere through the Georgian period. In 1775, one ship of the East India Company carried to London 2,236 pieces of paper hangings, but the trade remained marginal in commercial terms and accounts of the actual purchasing of wallpaper in Canton are very rare.

In Europe, many individual 'Chinese rooms' were installed, as well as whole Chinese palaces, with wallpaper as a prominent feature. An example like that shown (*88*) must have formed the total decoration of such a room. One of three similar panels in the Museum, it must originally have formed part of a very much larger set, as it carries the numeral '20' in Chinese at the bottom. It is closely analogous to other known sets which show the various stages of the tea and porcelain industries, subjects which also dominated small-scale export painting. The similarity in style is so close that it raises the possibility that one or two workshops might have been responsible in Canton for what, despite its impact on western sensibilities, remained very much a sideline occupation in the scope of the total export economy. The surviving sections of this set show a mixture of Chinese mythological characters with a hunting scene which may have been more to the taste of the English purchaser than of the manufacturer. Sets like this, with one continuous scene stretching across the separate panels, must have been considerably more difficult to install than those of the type where each vertical

88

PANEL OF WALLPAPER (detail)
Watercolour on paper
A hunting scene
About 1790–1800
395 × 118.2 cm
E.1181-1921
Darby Gift

panel is in effect a self-contained scene, usually of botanically implausible plants and birds (*89*).

The manner in which wallpapers are painted is close in many particulars to that used to produce painted silks (p.26). Not only the use of a background colour and the general palette employed, but the preliminary outlining (again there is no evidence that block-printing was ever used), the colour-washing and the final metallic high-lighting of the colours are shared with some furnishing silks. It is quite possible that painted silks and wallpapers were in fact produced in the same workshops. The paper on which these panels are painted is almost always of Chinese manufacture, and there is a tendency for the size of the sheets of paper used to increase as the eighteenth and nineteenth centuries progressed. Thus panels from the middle of the eighteenth century are often composed of a patchwork of overlapping small sheets, on which the outline was drawn before they were stuck together. The hunting panel (*88*) is made up of six 58 centimetres high sheets of paper which run across its whole width, plus a narrow strip at the bottom. The later floral example (*89*) is composed of only three, much larger, sheets plus a narrow strip.

The decorative impact of these wallpapers has ensured that they, more force-fully than any other type of Chinese export artefact, have remained a live presence in interior design to this day. Early examples are still being installed in new settings, as well as being copied and used as sources of interior decoration by manufacturers of wallpapers and furnishing fabrics today. No longer imported exotica, they bring with them coveted associations of an idealized 'country house' way of life. vw/cc

89
PANEL OF WALLPAPER
(detail)
Watercolour on paper
A potted lychee plant, flowering shrubs and birds
About 1810–1830
243.9 × 122 cm
E.2853-1913

Painting

WORKSHOP painting, painting executed by unnamed artisans in conditions of batch production, often with several sets of hands working on the same object, has received relatively little attention in studies of Chinese art. However it is clear that there was a rich history of such representation, organized for purposes far removed from those of the 'high art' tradition, with its complex lineages of masters and schools, and its highly developed tools of stylistic analysis. From the fifteenth century, it was possible to buy 'off the peg' paintings suitable as gifts for a departing friend, while in the sixteenth century large quantities of anonymous paintings showing intricately detailed scenes from Chinese mythology and history were exported to Japan. Some of these works even found their way into early European collections of curiosities. What we call 'export painting', which to a greater or lesser extent attempts to assimilate European conventions of pictorial representation, thus had deep roots in conventions of Chinese picture-making.

From the early eighteenth century, 'China pictures' formed a regular part of private trade from Canton, shipped in boxes which could contain as many as four hundred individual sheets. Early examples seem to have been mostly of birds and flowers, a very traditional area of Chinese workshop painting, and one which, initially at least, showed few signs of adopting western conventions. Thus in a set of botanical watercolours dating from about 1760 (90, 91), the composition and palette, as well as the method of rendering rocks and of signalling 'sky' by unpainted areas of the paper, are well within the bounds of the rather conservative treatment given to botanical subjects in book illustration and painting on porcelain.

The technical resources employed here are purely Chinese. However this is not the case with reverse painting on glass, the main material of which was not manufactured successfully in China and had to be imported from Europe (92). Glass was brought to Canton to be installed in furniture (69), and began to be used in China for lamps and even for window glass, though this remained rare until the nineteenth century. The romantic, even sentimental subject matter of this example is typical, and reflects western, not Chinese, conventions of both painting style and social representation. In Chinese terms it is decidedly risqué.

The earliest identifiable Canton painting workshop to have catered specifically for western clients is that known as Pu-Qua. This name appears on a set of stipple engravings published in London in 1800 as *Costume of China* by George Henry Mason, and which copied a set of watercolours in a Canton export style. Active at least from the 1780s, the 'Pu-Qua workshop' is best known for these large sets (over one hundred leaves) showing the various trades and occupations of the city (93). Several of this series exist, strikingly similar in detail for what are after all hand-painted images. It seems certain that even at this early date standard sets of

90 *(top)*
'FOREIGN ROSE'
(fan meigui)
Watercolour on paper, from a set of twenty-four sheets
About 1760
26.4 × 29.6 cm
D.1289-1889

91 *(bottom)*
FLOWERING WHITE
CABBAGE (*bai cai hua*)
Watercolour on paper, from a set of twenty-four sheets
About 1760
26.4 × 29.6 cm
D.1271-1889

番玖挂

白蘂花

templates, or 'blanks', were used in the workshop to produce near-identical editions of sets of paintings. The analogy with the practice of Chinese porcelain enamelling workshops is here quite close.

'One-off' commissions were still a possibility. A small album, painted on a paper specially manufactured by the Whatman factory in Kent to withstand the Asian climate, was ordered for an English customer in 1796. It shows figures emblematic of various ranks in Chinese society (*94*), as well as some of the stages of tea growing. Sets showing the processes of tea growing, as well as of porcelain and silk manufacture, were one of the staples of export painting workshops. Although by about 1800 these were well-assimilated to western pictorial conventions, they in fact drew on a long-indigenous tradition of representing agriculture and silkworm rearing, reassuringly idyllic sets of scenes which state the timeless and harmonious hierarchy of the ideal Confucian social order. The Museum's set depicting the processes of the tea industry (*95*) is again one which exists in several versions elsewhere, sometimes with the costume of the western merchant on the left of the scene updated to show a top hat in place of the powdered wig. This suggests that the workshop templates may in some cases have had a working life of decades.

Another stock theme was views of the area in and around Canton, showing in particular the river frontages of the foreign factories. Early examples can be painted on silk (*2*), and take the format of handscrolls, but by the nineteenth century they assumed a generally western 'landscape' format. Two views (*96*, *97*) from a set of five painted in about 1850, on paper made from the pith of *Tetrapanax papyrifera*, show the waterfront at the now-decayed Portuguese settlement of Macao, and its rival, the burgeoning British colony of Hong Kong, which had been annexed in 1843 following the First Opium War. They almost certainly emanate from the workshop operated by Guan Lianchang, known to foreigners as Tingqua. He was the son of Guan Zuolin (Spoilum), the earliest export painter to work in a western oil technique, and the brother of the most successful exponent of that technique, known as Lamqua. It was the Lamqua studio which produced the oil portrait of Wu Bingjian (1769–1843), most renowned and successful of the Chinese merchants engaged in overseas trade, which exists in several versions (again it should be thought of as an edition rather than an 'original'), and which was copied in the watercolour studio of his brother (*98*). This image of the noble and trustworthy Chinese was to be supplanted as the century went on by a series of stereotypes of an ever more openly racist tendency. By the end of the nineteenth century and into this century painting for export was dominated by crude views of a Chinese never-never land (*99*), which bore absolutely no relation to the reality of a nation struggling for a place in the modern world. CC

92
PAIR OF LOVERS
Reverse painting on glass, with gilded wood frame
About 1760–1780
43.7 × 28.7 cm
F.E.26-1970
Hon. Dame Ada MacNaghten Bequest

93
SELLER OF
FLOWERING PLANTS
Watercolour on paper, from
a set of one hundred sheets
Pu-Qua workshop
About 1790
34.1 × 41.5 cm
D.131-1898

7

Tsŏ [?]

Infantry or Foot Warrior

5

D.899-9

督 提

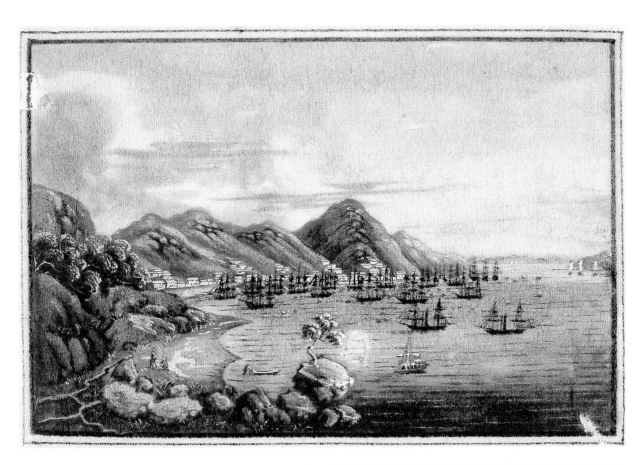

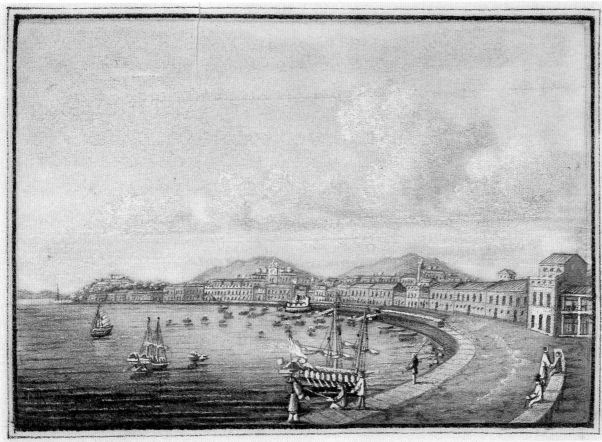

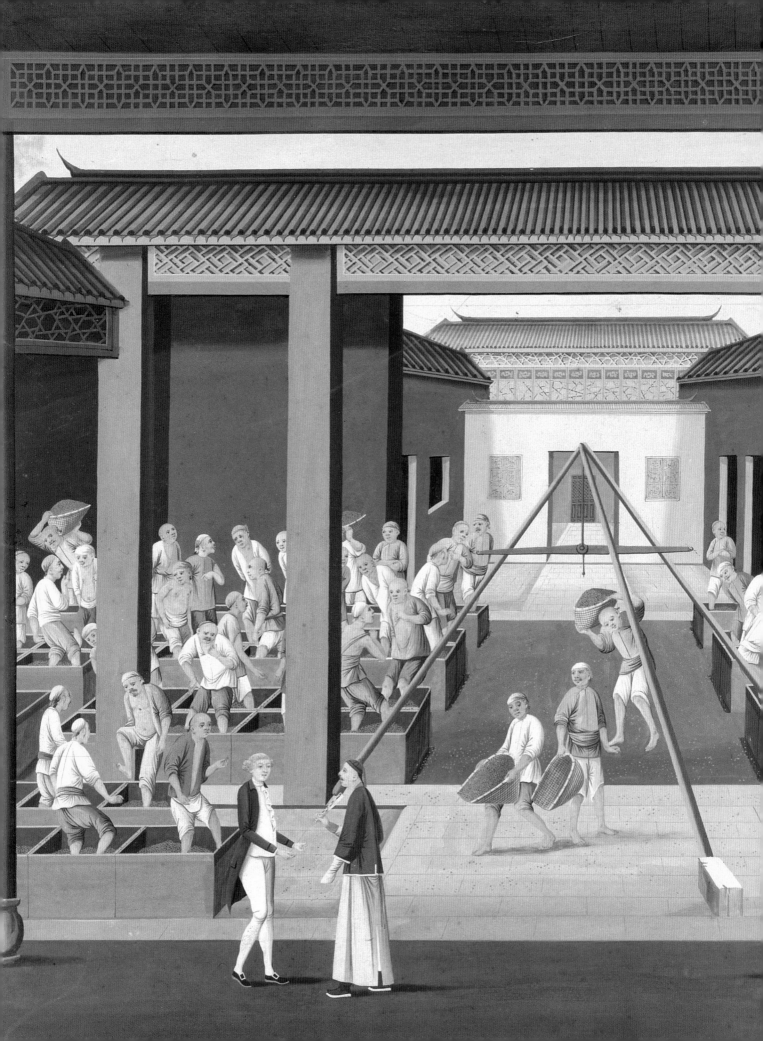

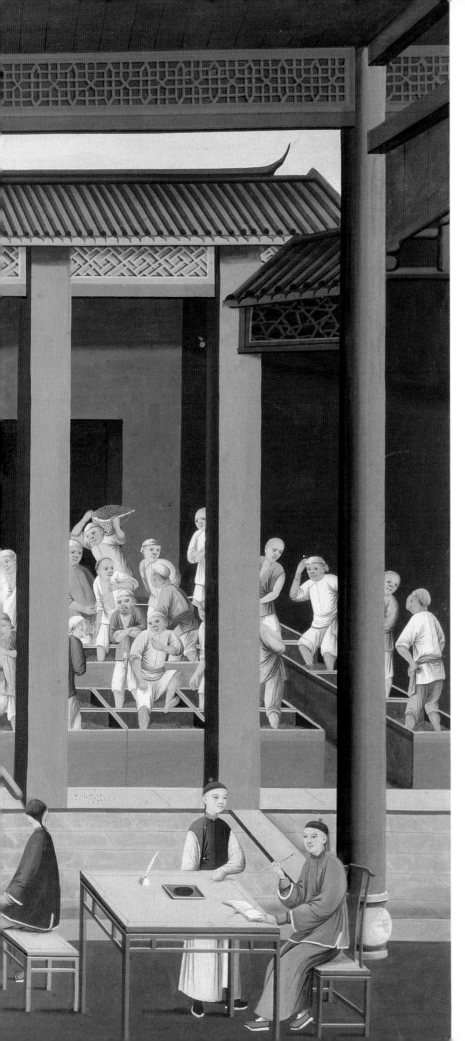

97 (left)
TEA PACKING WAREHOUSE
Watercolour on paper, from a set of
twelve sheets
About 1800
54 × 39.6 cm
D.357-1894
Mackenzie Gift

98 (overleaf left)
PORTRAIT OF WU BINGJIAN (HOWQUA)
Watercolour on paper
Tingqua workshop
About 1840–1850
24.8 × 18.9 cm
E.816-1937

99 (overleaf right)
EMPRESS
Watercolour on pith paper, from a
set of thirty-six sheets
About 1900
33.5 × 21.5 cm
E.3196-1934
Hildburgh Gift

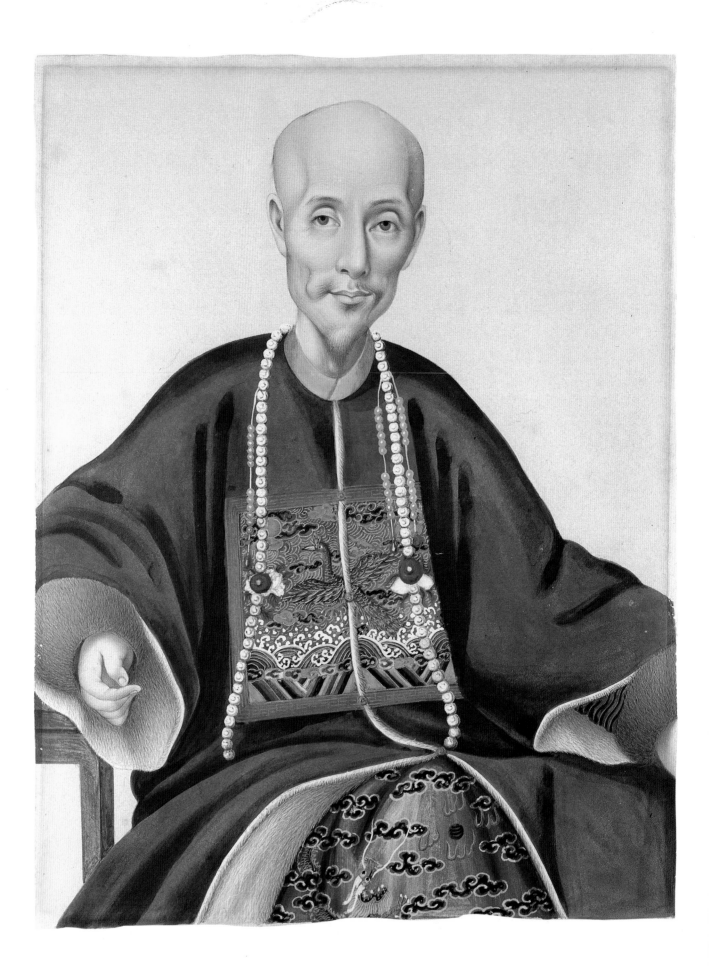

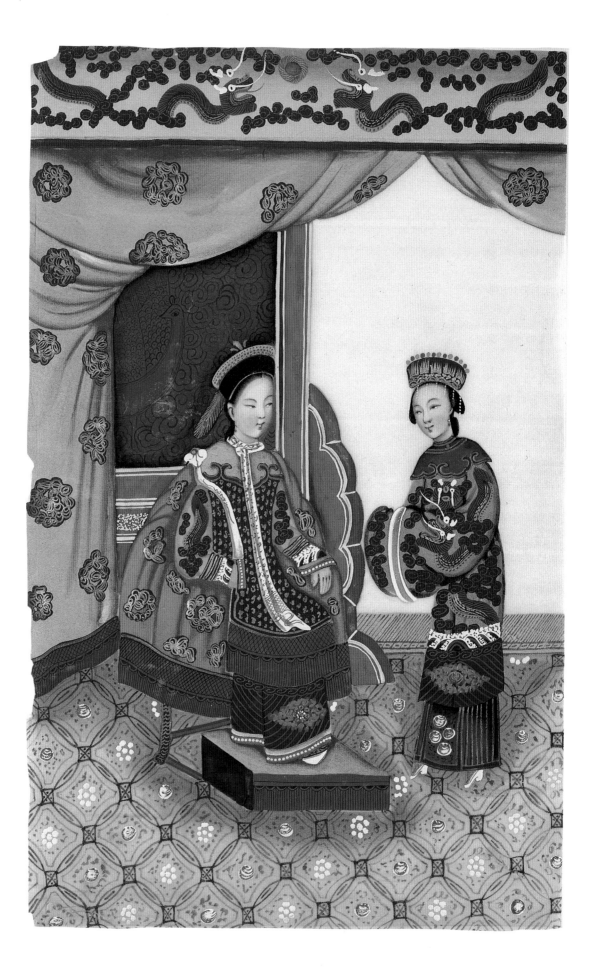